Published in 2024 by Hardie Grant Books

Hardie Grant Books (London)
5th & 6th Floors
52–54 Southwark Street
London SE1 1UN

hardiegrantbooks.com

British Library Cataloguing-in-Publication Data.
A catalogue record for this book is available from the British Library.

15-Minute Art Watercolour
ISBN: 9781784886820

3 5 7 9 10 8 6 4
Publishing Director: Kajal Mistry
Commissioning Editor: Kate Burkett
Senior Editor: Chelsea Edwards
Design and Art Direction: Double Slice Studio
Illustrations: Jola Sopek
Copyeditor: Clare Double
Proofreader: Caroline West
Production Controller: Martina Georgieva

Colour reproduction by p2d
Printed and bound in China by C&C Offset Printing Co., Ltd.

MIX
Paper | Supporting
responsible forestry
FSC
www.fsc.org
FSC™ C018179

15 Minute Art

Watercolour

JOLA SOPEK

Hardie Grant

BOOKS

THIS JOURNAL BELONGS TO

- -

THE PROJECTS

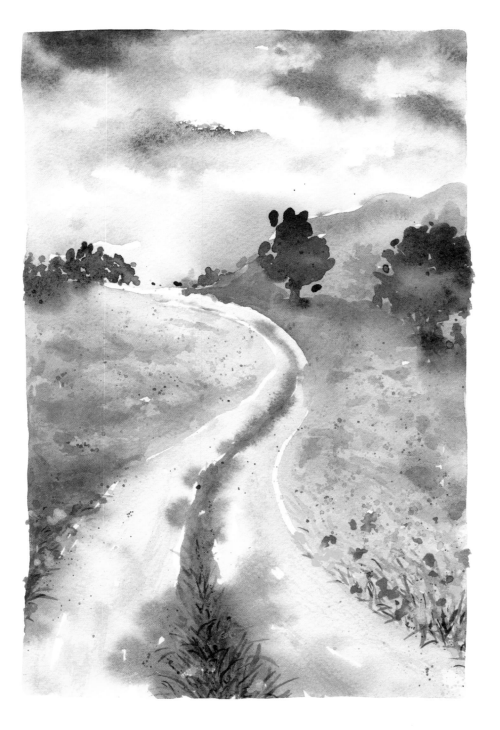

Hello
and
Welcome

Hello, my name is Jola Sopek. I'm a freelance illustrator self-taught in painting, and head-over-heels in love with watercolours!

My journey of creative expression started with photography. At the age of 12 I became obsessed with documenting scenes from daily life with a camera. I became a low-key paparazzo, taking photos of all the mundane moments. To me a photo of a shoe, someone's hair or a subtle shadow on a wall makes a beautiful image and a memory to be cherished. I continued taking thousands of snapshots until my mid-20s, when I graduated with a Master's degree in Photography from the University of Brighton. I must have been looking for a new hobby subconsciously because when I stumbled upon watercolours by chance, I was hooked immediately.

That was about five years ago, and now I am a full-time watercolour illustrator. I still take photos, but for my own pleasure or as a reference for paintings. At first, I had no idea how to use watercolours. I applied thick layers as one would with acrylic or oil paints. As I continued messing about, I started learning better techniques with the help of various tutorials, as well as the age-old trial-and-error method, until I started noticing progress in my sketches. I focused on painting my favourite subjects – fruit, plants, foliage, animals – and I can now appreciate that my photography training helps me to spot joyful colour combinations, intriguing textures and eye-catching compositions.

Soon after I realised that watercolours made my heart jump in excitement, I set up an Instagram account, @jolapictures, which has been a pivotal part of my artistic growth. I gathered a lot of followers and was lucky to be presented with some amazing opportunities. I now accept commissions for food and botanical illustration projects, work with businesses, create board games and teach watercolour techniques in person and online.

My main goal is to inspire as many people as possible to pick up a paintbrush and put some paint on paper to unwind. I call watercolour painting art therapy because nothing relaxes me more than getting lost in colourful sketches. Your doodles can be simple; the transparency of watercolours allows for a lot of effortless abstraction. I hope the projects in this book will give you a glimpse into my immense fascination with watercolour, show you a few of the endless possibilities of the medium, and motivate you to discover your favourite subjects and colour palettes. The exercises are organised from easiest to a little more advanced by the end. Practise along with me to paint fruit and vegetables, animals, sea life and other inspiring topics!

Remember that creativity is for absolutely everyone, no matter if you were 'bad at art' as a kid, or if you feel that you don't have enough talent. Your paintings will get better and better as you keep practising regularly and develop muscle memory. As long as you have the desire to learn and feel deeply excited when painting, that is all you need to progress.

Happy painting and playing!

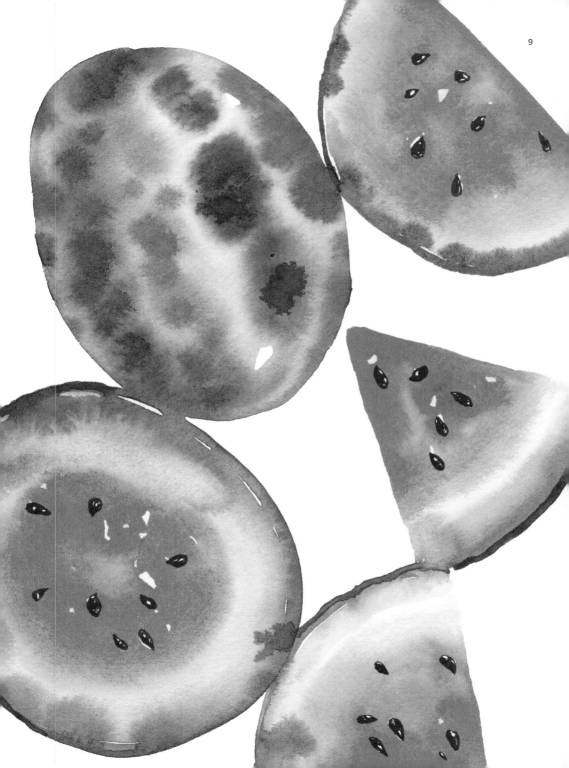

Tools and *Materials*

Picking art materials can be confusing at first – there is a lot of choice out there! To keep it simple, invest in a few staple items and familiarise yourself with them before building up your collection further. Art supplies shopping is fun, but it is easy to buy things you don't need and become overwhelmed as a result.

If you can't find the brands I list below, don't worry. Go to your local art shop and ask staff for advice, read reviews online, or do what I did: buy just one sketchbook or a pad of paper, experiment with one or two brush brands, try one make of paints and see how you feel about each of them. You can learn the differences between brands at your own pace.

You need these essentials to get started:

- Watercolour paper (in a pad or sketchbook)
- Two to three round-shaped paintbrushes in different sizes
- A set of watercolour paints (in pans or tubes)
- Paper towels (kitchen roll)
- A few jars of water
- A mixing palette (ceramic, plastic or metal)
- A pencil and sharpener
- A kneadable eraser
- Scrap paper for testing colour mixes

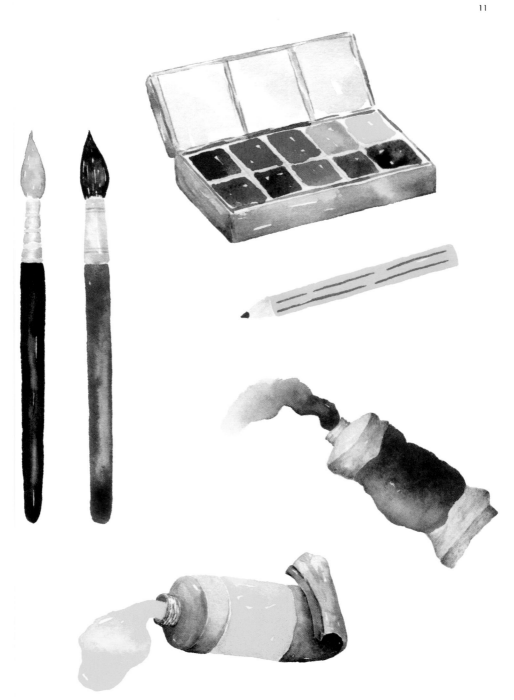

WATERCOLOUR PAINTS

Some of my favourite paint brands are Winsor & Newton, Etchr Lab, Daniel Smith, Roman Szmal and MaimeriBlu. I use many other brands regularly too – I can't recommend just one, as I like to mix and match! All the brands I mention make high-quality paints, but depending on where you are in the world you may have access to others. Generally, more expensive paints will give better results and last longer because they are highly pigmented – and with watercolours, a little goes a long way.

Watercolour paints come in tubes (containing liquid paint, similar to acrylic or oil tubes) and pans (hardened paint in tiny plastic containers). I use both types daily in my studio. Tubed watercolours are easier to activate – squeeze some paint onto a palette, apply water to the brush and you are good to go. Pans require activating with a few drops of water so that the pigment can be picked up with a brush. However, pans are portable and therefore travel-friendly, whereas tubed watercolours are more suitable for using at home.

You can purchase a ready-mixed palette of multiple shades, meaning that you don't need to mix your own tones. However, if you would like to deepen your understanding of colour mixing, I recommend buying individual tubes or pans in the primary colours (red, blue and yellow) so you can mix a plethora of shades. I suggest buying six colours – a warm and a cool shade of each primary (see page 20):

- A warm red, such as Cadmium Red or Scarlet Lake
- A cool red, such as Quinacridone Magenta or Carmine
- A warm yellow, such as Indian Yellow or Cadmium Yellow
- A cool yellow, such as Lemon Yellow or Bismuth Yellow
- A warm blue, such as Ultramarine Blue or Prussian Blue
- A cool blue, such as Phthalo Blue or Indanthrone Blue

WATERCOLOUR PAPER

It is best to use dedicated watercolour paper, but you can use mixed-media papers too. When choosing watercolour paper, pay attention to its thickness. I recommend a minimum of 300gsm (grams per square metre), which can withstand and absorb water application, as thinner papers tend to buckle and wrinkle. You can buy paper in glued pads, as sketchbooks or as large, loose sheets, which can be trimmed down to a desired size. Having said that, the paper in this book is 180gsm which can withstand some water for quick practice, so feel free to sketch on the empty pages next to the exercises.

Then, very importantly, there is the texture of watercolour papers. My favourite type is cold-pressed – this means it has a slightly irregular texture, which allows pigments to 'sink' into the paper. Hot-pressed papers are totally smooth, which can be beneficial for certain projects, but personally I rarely use them because they dry slightly quicker. There are also rough-textured papers, which are extremely uneven – if you are a beginner, I'd avoid them as they can be tricky to work with.

Some of my favourite paper brands are Stonehenge Aqua Coldpress made by Legion Paper, Hahnemühle papers, Koval Sketchbooks, Strathmore and Canson. As with the paints, there are many other great brands to experiment with.

PAINTBRUSHES

I'm a fan of synthetic brushes. These days they are as good as animal-hair ones, and most manufacturers produce them. I recommend you buy just two or three different sizes at first, choosing from small, medium and large. The most versatile shape is a round brush that comes to a thin, sharp point at the tip. A round brush allows for different strokes using varying degrees of pressure. Note that when you open a new brush, the bristles will be covered with a protective solution that keeps them stiff in transit. To remove, simply swirl the brush in clean water until you feel the hairs soften.

MIXING PALETTES

I prefer to mix paint on a ceramic surface as the paint flows well on it and it's easy to clean. You can buy a painting ceramic palette from art shops, but you could also repurpose an old white plate or serving dish – it is best to have a lot of mixing space. Plastic and metal palettes are also available. Sets of watercolours usually come in a box with mixing palettes attached.

WATER JARS

If you are working at a desk, I recommend using at least two, but ideally three, jars of water when painting. You will be switching between many colours and diluting paints. When changing the colours, clean off your brush in a dedicated 'dirty water' jar before reapplying clean water to your brush from a 'clean water' jar to mix the next colour. A third jar is useful for the halfway step. Once you have removed most of the paint in the 'dirty jar', clean your brush off again in the middle jar, as there will usually be some residue still present on the bristles. Then proceed to apply clean water from the 'clear jar' – this ensures that your new colour mix remains uncontaminated.

PAPER TOWELS

Essential for getting rid of excess water and pigment from the brush. When you are diluting paint on your brush, keep a paper towel to hand to get rid of excess water from the bristles and avoid creating puddles or accidental drops of water.

PENCILS

I usually opt for HB graphite pencils for sketching. Important note: make your pencil strokes as delicate and light as you can. Being a naturally transparent medium, watercolour will not cover up pencil lines well, so keep your sketches as minimal as possible. If you want to avoid any lines showing, you can use soluble watercolour pencils for sketching, too. You'll also need a pencil sharpener.

ERASERS

I recommend you buy a kneadable art eraser. Soft 'putty' erasers are delicate and won't damage the surface of watercolour papers.

DRYING DEVICE

You can use a hairdryer or a heat tool to speed up the drying process for your paintings. Watercolour layers can sometimes take a while to dry, so feel free to use a drying device. I used a heat tool when creating a lot of the exercises in this book.

Techniques

You may have heard that watercolour is a difficult medium to master. Being a water-based medium, it requires you to control the flow of the pigment but at the same time learn the art of 'letting go' of said control. There are many techniques that you will discover as you keep practising – I feel that I'm still learning every day, which is why I find watercolours endlessly fascinating!

Remember that your paintings will look slightly different when they have dried completely due to the water evaporating, which is not the case when painting with acrylics or oils. The surprise element is an integral part of the watercolour journey and has to be embraced. The list of techniques listed below is not exhaustive, but they are the most fundamental ones and they will get you off to a solid start.

GRADIENTS

You can test the potential of any of your colours by making simple gradients. Apply water to your brush and mix a generous amount of pigment in your palette. Apply the saturated colour to the paper and gradually keep adding water to the mix until it becomes almost transparent. This exercise shows us that we can create beautiful paintings using just one colour if we learn how to control the saturation of the paint mixes.

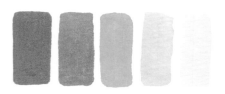
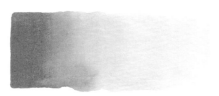

WET-ON-DRY / WET-ON-WET

The wet-on-dry method means applying wet paint to dry paper. A lot of the exercises in this book are painted using this method.

As the name suggests, the wet-on-wet technique involves applying wet paint to wet paper. Start by putting down a layer of clean water onto paper, then load your brush with paint and drop some of it onto the water layer to watch the 'blooming' effects.

Wet-on-dry

Wet-on-wet

LAYERING

If you let a layer of watercolour dry completely, you can apply another one on top of it (I recommend three layers maximum, as it is easy to overwork the paper). If you continue painting without waiting for the first layer to dry, your colours will merge. Different ways of layering will give you lovely colour effects, so experiment!

Dry layering

Wet layering

HIGHLIGHTS

Since we don't use white paint in watercolour painting, in contrast to most other painting media, we have to imitate highlights in a different way. To do this, leave a little empty gap of white paper in a shape you are painting to create dimension and showcase where the highlights fall in your illustrations.

BLEEDING

While washes of paint are drying, you are likely to notice a 'bleeding' effect in your watercolour illustration. This occurs when one part of the painting has a little less water content than another section and hence dries more quickly, creating a visible 'border'. Some people avoid this effect, but personally I absolutely love it – it is a uniquely watercolour look – and I try to incorporate it into my work often.

BRUSH PRESSURE

Practise applying varying pressure with your paintbrush by making thinner and thicker lines. This is a fantastic muscle memory exercise, which you will use in most of your paintings.

Apply hardly any pressure to paint 'hairline' strokes by holding your brush upright. Press down harder, tilting the brush at a 30-degree angle, to paint thicker lines. Then, combine the hairline with the thicker strokes in one smooth movement. This will be very useful for painting leaves in some of the upcoming exercises!

Thin hairline strokes

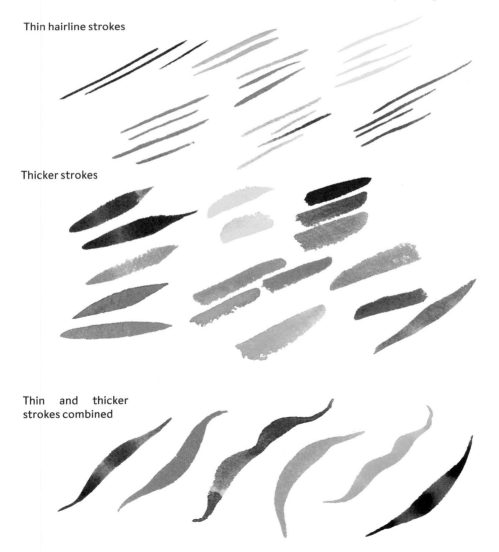

Thicker strokes

Thin and thicker strokes combined

Colour
Story

'Colour theory' may sound intimidating, but it is not hard to grasp. Once you understand the basics, you will naturally notice which colours go together beautifully, and which should be mixed carefully as they can create duller tones. You will find that your watercolour journey becomes more satisfying with this knowledge.

The colour wheel is made up of the three primary colours: red, blue and yellow. A primary colour cannot be obtained by mixing any other colours. Primaries are the essence of all other colours, which can be created by mixing the primaries.

The secondary colours are green, orange and purple. They are mixed from two primaries at a time. Tertiary colours are further tones such as yellow-orange, blue-green and red-purple; they are obtained by mixing a primary with one secondary colour.

In the context of watercolours, it is vital to discuss the temperature (warmth or coolness) of the primaries you use – something that I have often found to be overlooked in tutorials. You may remember trying to mix purple in an art class at school and instead of a vivid violet you ended up with an unflattering brown. This is due to the temperature of your primaries!

To elevate your understanding of the colour wheel, notice the difference the colour temperature makes in the two colour wheels shown opposite. These wheels demonstrate 'split primaries', showing how primary colours may alter according to temperature (see the list of suggested warm and cool primary paints on page 12).

I'm in awe of the difference between the warm and cool greens and oranges. Distinguishing the temperatures of the primaries will enhance your colour-mixing skills.

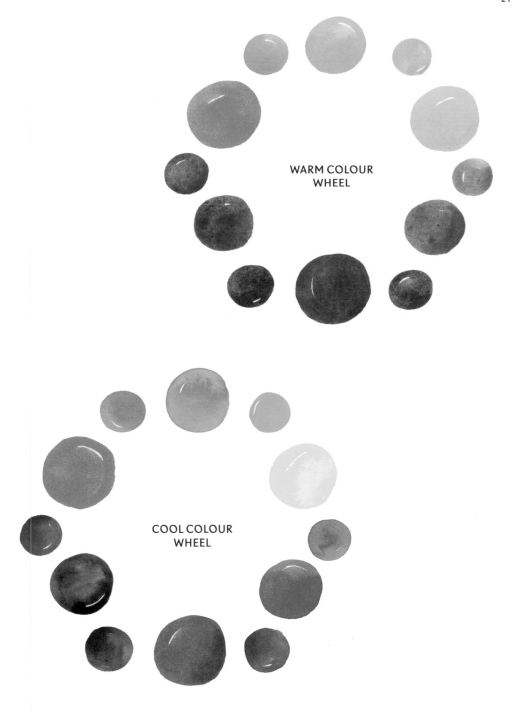

WARM COLOUR
WHEEL

COOL COLOUR
WHEEL

ANALOGOUS COLOURS

Blue / Green

Red / Yellow

The colours sitting next to each other on the colour wheel are called 'analogous' and they make for a harmonious palette. Some examples of these are blue, blue-green and green; red, yellow-red and yellow.

The colours directly opposite each other are called 'complementary' – they contrast with each other. Complementary colours can give a powerful 'pop' to your paintings; imagine painting a green tree with some red apples on it, and you have created an eye-catching colour composition using complementary colours.

If you mix complementary colours together in a palette, you will obtain a shade of brown. This can be advantageous; you can use a tiny bit of a complementary colour to darken your colour of choice. For example, when painting green leaves, I mix a tiny bit of red into my green paint to make it more naturalistic. If I'm after a less vibrant yellow, I add a very small amount of purple, and so on. This mixing method is predictable and effective, and darker colours mixed like this look more natural than if you were to add black paint to darken your colour.

Take some time to experiment with mixing colours according to the wheel. Remember that to lighten a colour, you only need to add extra water to the paint mix. White watercolour paint is not necessary – it is an opaque pigment and may make your colours look chalky. Use it only if you need a pastel shade. Finally, note that combining all the primaries will give you a black.

COMPLEMENTARY
COLOURS

These are mixtures of complementary colours (the
colours directly opposite each other on the colour wheel).

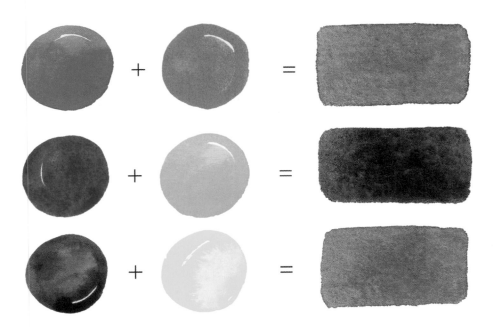

Mixing all cool and warm primaries makes black

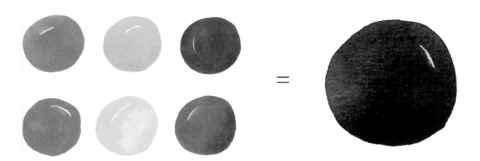

Sketching

I have included sketch outline templates for all the projects at the end of the book. They will help you if you are not confident at drawing and feel a bit intimidated by it. Feel free to analyse them and use them as references for your own sketches, or use tracing paper to go over the outlines and transfer them to the paper of your choice – either a separate watercolour sheet or the empty practice pages in this book.

The most important thing is to use your pencil lightly. Make your strokes as delicate as you possibly can so that they aren't too visible underneath the layers of watercolour. Unlike more opaque painting media such as acrylic, gouache or oil, watercolour is known for its transparency and therefore pencil lines may

show through the paint. The more delicate your sketch, the better. I make my drawing sketches extremely simple, and I only add details to my illustrations with watercolours later.

My outlines are not rigid guides that you must follow. A lot of my day-to-day illustration work involves loose strokes, slight shape irregularities and imperfections. The benefit of painting natural subjects such as food, plants, flowers and animals is that they are rarely perfectly shaped. One apple will be rounder or wonkier than another, and so on. Don't worry about making the sketches perfect!

Moreover, the illustrations in the book are merely an inspiration for you to get you started – by all means, experiment with your own versions. If you would prefer to paint a branch with twelve leaves instead of nine, please go ahead. If the colours I use don't speak to you, feel free to choose others. It is important to be able to use references, but also add your own personal twist to them.

Finally, I would encourage you to take your own reference photos when you are out on a walk, cooking with colourful ingredients, or whatever else may take your fancy. I find a lot of inspiration in daily life; taking your own snapshots is often a great way to paint something unique later. Equally, you can look for inspirational images in books, magazines or online – just remember that if you show your work publicly afterwards you need to credit the author or the source you have used.

Project 01

Stripe Pattern

An essential exercise to get the hang of wet-on-wet effects! Pick just one paint colour to make it simple and uncomplicated. Your choice, but keep it monochromatic.

STEP 01

Mix a rich colour (I chose blue) and paint a vertical line. To paint the second one, add more water to your brush to dilute the blue a little. Keep adding more water (and hence removing excess pigment) to paint a few more lines until they are nearly transparent. This shows you the tonal variety you can achieve with just one colour.

STEP 02

Paint a deep blue line again. Quickly get rid of excess pigment and add more water to your brush to paint the second line, this time touching the first shape. Make sure the first line is still wet when you introduce the second, to ensure the wet-on-wet merging effect works its magic.

STEP 03

Practise painting a few clusters. Paint a blue line, then a transparent one right next to it; quickly switch back to blue and paint a third stroke on the other side of the transparent one. Then paint lines with different amounts of water just like in Step 1, but this time touching them at the sides as you move along.

STEP 04

Make a cluster of multiple lines. Paint them at various angles and with different ratios of water to pigment in order to achieve a dynamic colour scene.

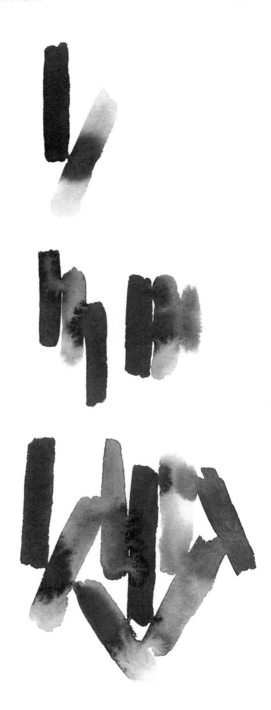

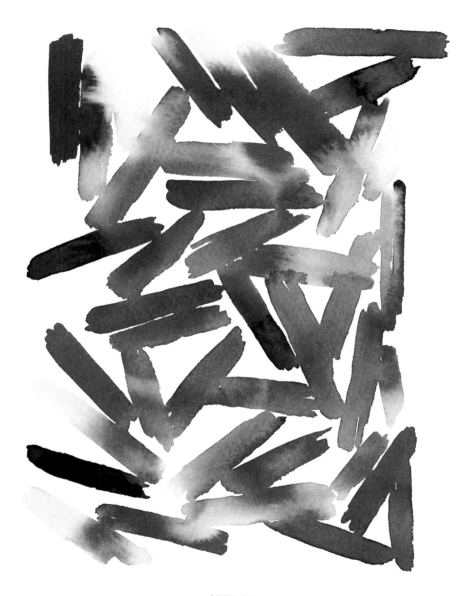

STEP 05

Grab a bigger sheet of paper and fill it with this monochrome pattern. The quicker you paint, the better, as you need the previous stripe to still be wet so that the subsequent one can merge with it. Vary the ratio of water to pigment for every stroke and try to immerse yourself in the hypnotic watercolour process.

Project 02

Circle Pattern

This classic watercolour exercise is relaxing and fun. Making abstract shapes takes the pressure off choosing a specific topic to paint. Feel free to play around with other colours.

STEP 01

Mix a sunny yellow. Paint two circles with different amounts of water. The first should be rich in colour. Remove excess pigment and apply more water to your brush to paint the second, paler circle. Clean your brush completely, then mix a rich pink and repeat the same process.

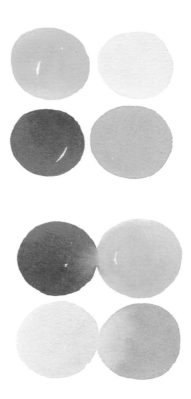

STEP 02

Fill your brush with rich pink to paint a circle. Quickly clean your brush and load it with rich yellow. When the pink is still wet, paint a yellow circle right next to it and connect them at their sides so the shapes merge. Repeat the process for two further circles, this time making the pink and yellow colours more transparent by applying more water than pigment.

STEP 03

Clean your brush completely and paint a transparent circle with just water. Quickly grab some yellow and paint a circle next to the transparent one, connecting the two shapes at the sides. The yellow pigment will 'travel' to the transparent shape and give it a hue. Reverse the process for the pink circles: paint a rich pink shape, then clean your brush completely and paint a transparent circle next to it.

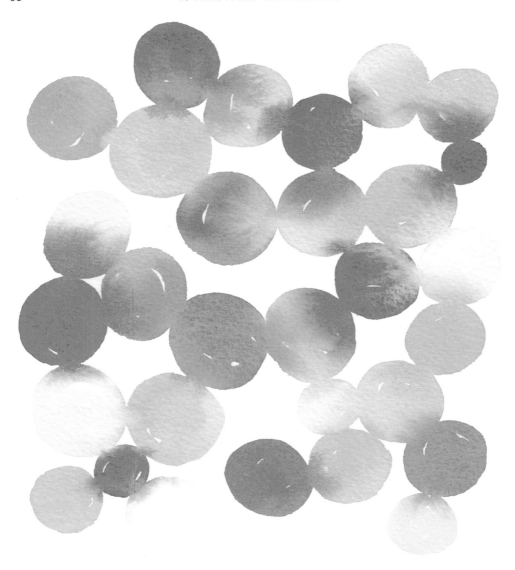

STEP 04

Start connecting more dots! Paint a rich pink circle. Then clean your brush completely and paint a transparent circle touching the pink one's side. Clean your brush again and load it with rich yellow to paint a third circle that touches the transparent one at its side.

STEP 05

Take your skills further to fill a whole page with the circular pattern. Paint each circle with a different amount of water and pigment, altering the quantities with every new shape. The quicker you move, the better, as it will allow for more wet-on-wet merging. Make some circles bigger and others smaller, to add more interest.

Project 03

Rainbow Carrots

Who wouldn't like to eat the rainbow? Try painting these fun, colourful carrots when you have a spare moment and need a creative pick-me-up.

STEP 01

Mix a few rainbow colours in your palette: orange, red, pink, purple, yellow – and some green for the carrot tops. First, practise painting some easy carrot shapes to familiarise yourself with the brushstrokes. Sketch a few green leaves by making thin lines; we will be adding those to the carrots later.

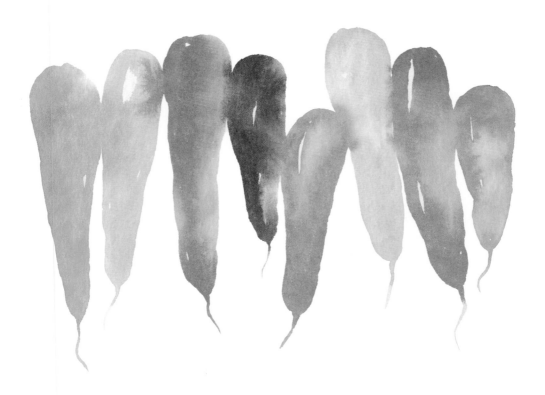

STEP 02

Sketch the carrots using outline 01 on page 228. Having prepared all the rainbow colours in your palette, start painting the carrots from one end of the row to the other. The process should be quick – as you finish painting one carrot, move on to the next colour and paint another carrot that is touching the previous one. Change the colour on your brush for each carrot.

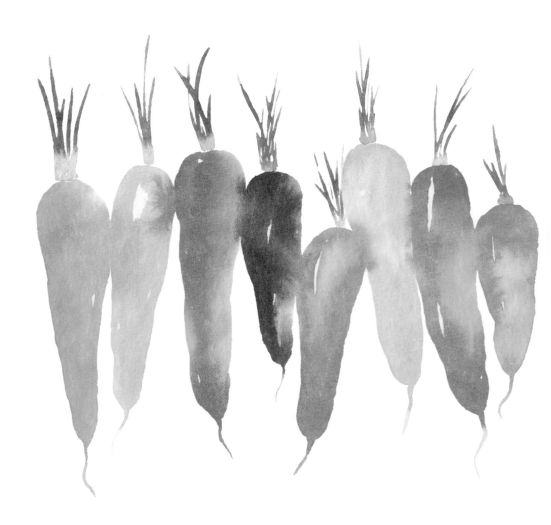

STEP 03

When the carrots are dry,
paint the green leaves as
practised in Step 1.

Project 04

Clouds

Simplicity and dreaminess at their best! Whenever I feel uninspired, I turn to simple shapes to reactivate my imagination and creativity. Watercolour cloud silhouettes are one of my go-tos – approachable and charming.

STEP 01

Using outline 02 on page 228, sketch the cloud. Mix a deep blue colour. Start filling in the shape of the cloud, using the darkest value of blue on the edge and adding more water to your mix as you move along. Leave a small empty gap to accentuate the highlight. The entire cloud should be painted in a steady but fast pace without many breaks, to prevent the paper from drying before you have finished filling in the silhouette.

STEP 02

Apply more water to your brush and continue filling the shape with a more transparent blue.

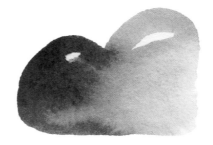

STEP 03

Add even more water and paint a section of the cloud with pale blue.

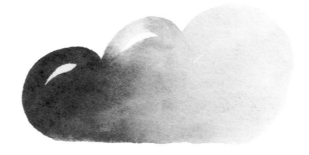

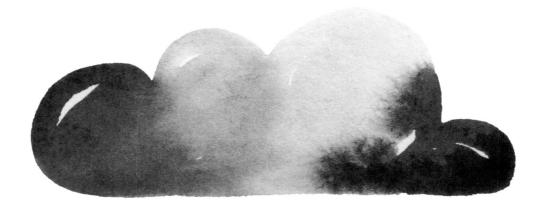

STEP 04

Go back to your palette and apply the darkest blue to your brush again to paint the remaining part of the cloud with a deep colour. Painting in this order, you will create a lot of contrast between the lightest and the darkest blues. If you enjoyed this exercise, feel free to experiment with other cloud shapes!

Project 05

Eucalyptus

This humble plant is a watercolour staple. Often featured on wedding invitations and menu designs, eucalyptus foliage is a charming illustration topic for beginners and more advanced painters alike.

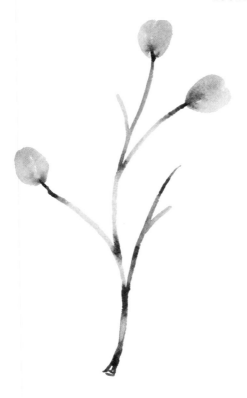

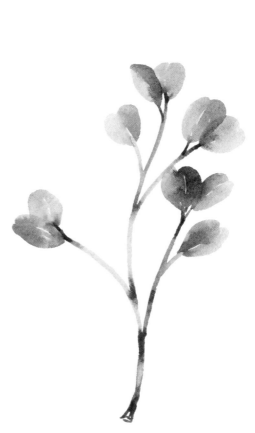

STEP 01

Sketch the branch using outline 03 on page 228. Mix a brown and a couple of greens, one with a bit of yellow, another with a touch of blue. Start by painting the brown stem. When it is still wet on the paper, quickly rinse your brush and change to a light, watery shade of green to add a few leaves at the tips.

STEP 02

Add a few more little branches and continue adding leaves at their tips as in Step 1. Make each leaf a different shade of green to create contrast. You can vary the intensity of the green by applying more water to your brush to dilute the paint or adding more pigment and less water to create a deeper green.

STEP 03

Make the composition fuller by adding more leaves. Overlap some of the leaves at the ends of the branches to create more dimension.

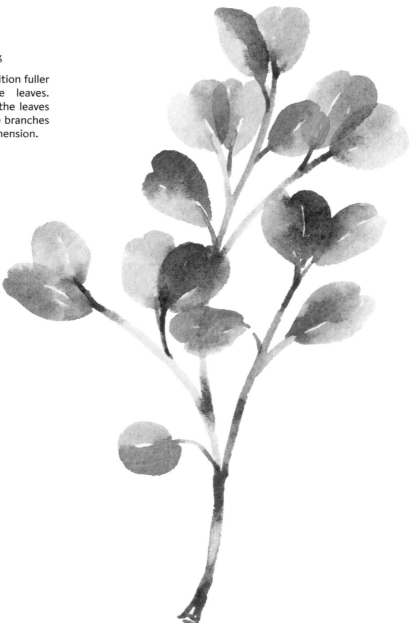

Project 06

Loose Flowers

Loose florals are a watercolour classic, and one of the first exercises I tried as a beginner. Try painting them on a handmade birthday card – it will put a huge smile on the recipient's face!

FLOWER PETALS

Mix red, pink and orange. Practise individual petals first – each one is formed of curved brushstrokes that make up an oval shape. Try to keep some empty gaps between strokes for a loose look. Vary the colours so that one side of each petal is more transparent than the other half, and make some of them double-coloured.

STEP 01

Practise painting a whole flower form, which is made up of four or five petals joined together at the centre. Use outline 48 on page 239. In the middle, add little dots to accentuate the heart of the flower.

STEP 02

Make a floral pattern of multiple forms with certain flowers touching at the edges. When you have finished one flower, quickly move on to the next before the previous one dries, to connect the two together. Continue in the same manner.

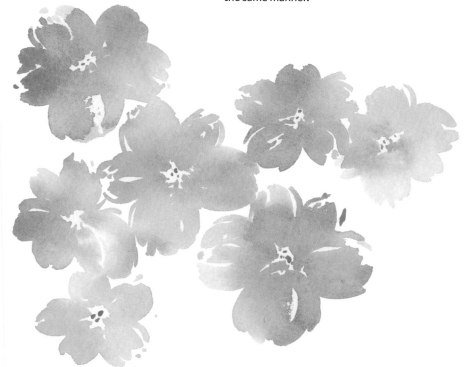

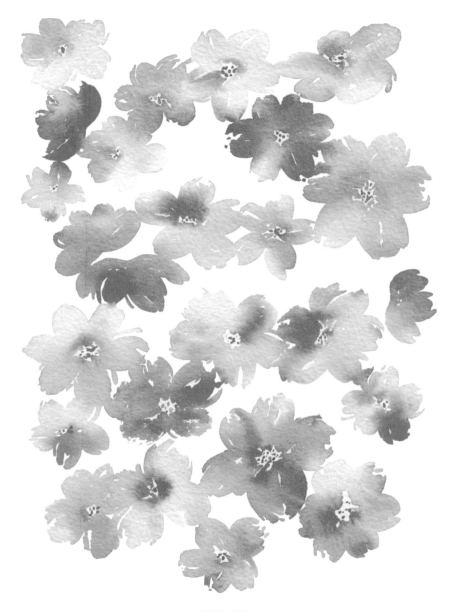

STEP 03

Fill a page with the pattern! Once you get the hang of the floral shapes, the process will become relaxing and even a bit hypnotic. The most important things are to vary the colours you are using and to control the transparency of your mixes to achieve contrasting tones.

Project 07

Bunny

I don't know about you, but I melt whenever I see a cute animal, and it makes me feel even sweeter to be able to paint them quickly in watercolour – a double treat!

STEP 01

Using outline 04 on page 228, sketch the bunny. Mix a warm brown and fill in the main body of the rabbit with this colour. Make the legs darker than the body by using more pigment. Add a little more water to your paint mix to paint the top part of the bunny and leave the tail area empty. Let dry. Feel free to use a hairdryer or a heat tool to speed up the drying process.

STEP 02

Using the same mix of brown, add the tiny head and the large ears. Create variety in the brown shades by adding more pigment or more water as you go.

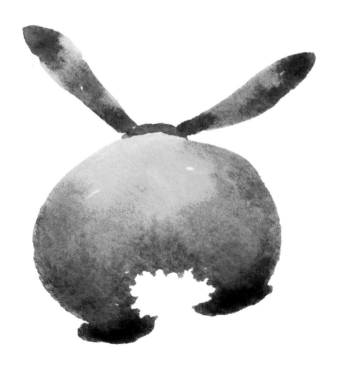

STEP 03

Mix a very light shade of brown with a touch of yellow, making sure you use quite a lot of water to dilute the colour so it's nearly transparent. With loose, dabbing strokes, add texture to the bunny's tail, leaving some empty space between the strokes to imitate the whiteness of the fur.

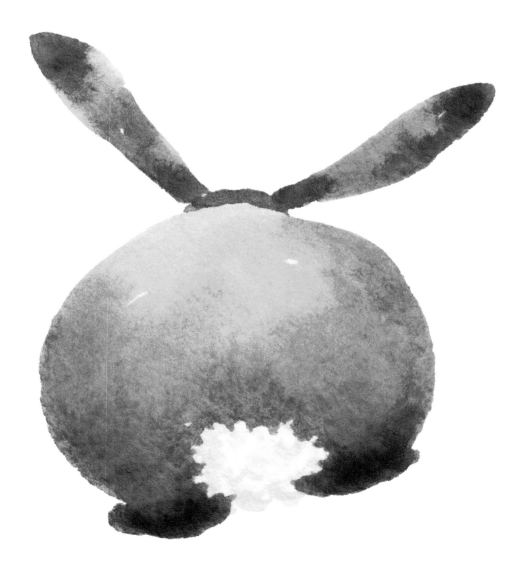

Project 08

Lemon

Citrus fruit is hands down one of my favourite subjects. Perhaps it is the vibrancy of the colours or an association with summertime – whenever I am stuck for inspiration, I turn to citrus!

STEP 01

Sketch the lemon shape using outline 05 on page 229. Mix a bright yellow. Try to paint the entire shape of the lemon quickly, starting from one side and placing more saturated yellow at the edge. Dilute the paint with more water as you move towards the middle.

STEP 02

Continuing quickly from Step 1, fill in the remaining shape of the lemon. The middle should be a lighter shade of yellow and the edges darker. Leave a few empty gaps within the shape as well, to imitate the fruit's natural highlights. Let dry.

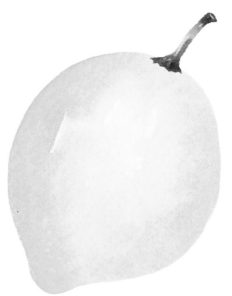

STEP 03

Mix a warm, earthy brown and, using a smaller brush, paint the lemon stem.

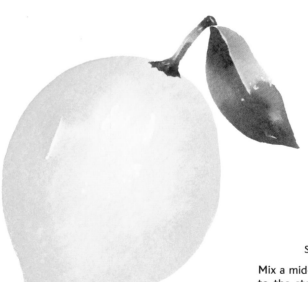

STEP 04

Mix a mid-green. Add a leaf to the stem. Paint it using two parallel strokes, using a darker mix for one side of the leaf and diluting the green with water to paint the second part.

Project 09

Lavender

These lavender sprigs are so simple, yet so joyful. Floral sketches don't have to be complex or overly structured to be effective. Sometimes a few brushstrokes are enough to evoke a feeling of calm.

STEP 01

Sketch the lavender shape using outline 06 on page 229. Mix a few shades of purple: one close to red, a bluish one and a dark purple one. Using small, dabbing brushstrokes, lay down little circular shapes in clusters, following the overall shape of a lavender sprig. Change your paint every few strokes for colour variety, and apply more water for certain strokes to achieve contrast and transparency in the paint.

STEP 02

Paint a few more sprigs, as you did in Step 1.

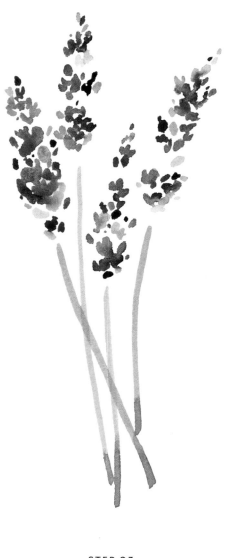

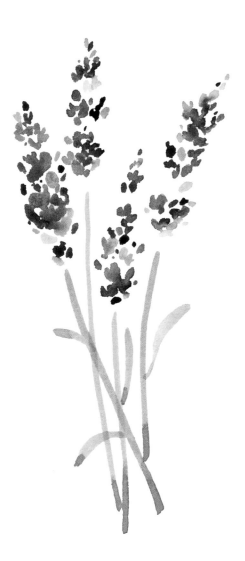

STEP 03

Mix a light green. Add a stem to each of the lavenders by painting a simple thin line. The stroke can be slightly curved, and you can also overlap a couple of the sprigs to add dimension.

STEP 04

Using the same green, paint a few simple leaves leading off the stems.

Project 10

Swallows

The magic of watercolours lies in how effortless yet effective the medium can be if you lean into its simplicity. Use the wet-on-wet method to paint these delicate swallow silhouettes.

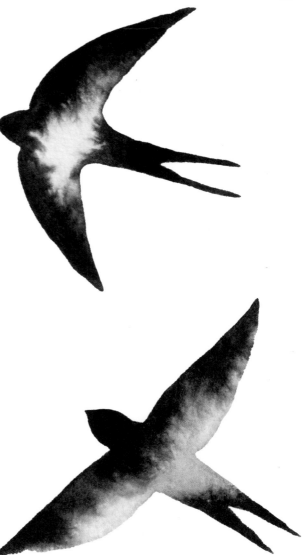

STEP 01

Sketch the three swallows using outline 07 on page 229 and mix a rich black. Start with the top swallow. Using the wet-on-wet technique, cover the entire silhouette with clear water and then drop in the black, moving in from the sides. It is best to apply the black at the edges – tail, wings and beak – and let the middle of the bird remain more transparent.

STEP 02

Paint the second swallow in the same manner. Remember that depending on which part of the bird you drop the pigment on first, that part will be darker than the rest.

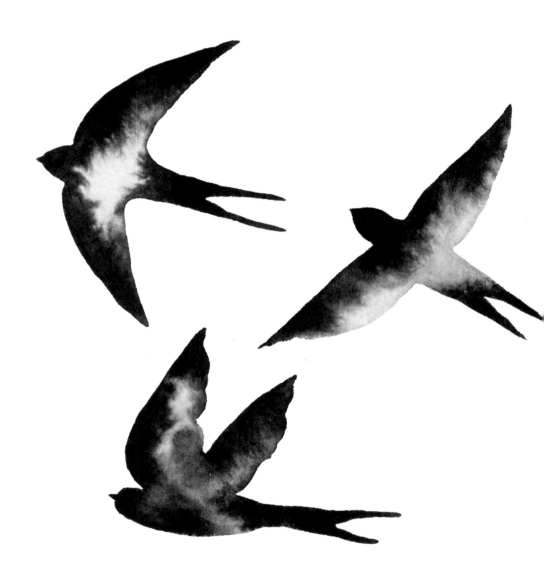

STEP 03

Repeat the process for the third swallow. Wet-on-wet painting allows you limited control over how exactly the pigment will place itself on the paper, so the paler patches will be distributed differently each time. This exercise is great for learning how to let watercolours just 'do their thing'!

Project 11

Double-coloured Leaves

One effective way to make
foliage illustrations a bit
extra is to paint leaves
using two colours instead
of just green. Experiment
with other pigments - after
all, this is your time to play!

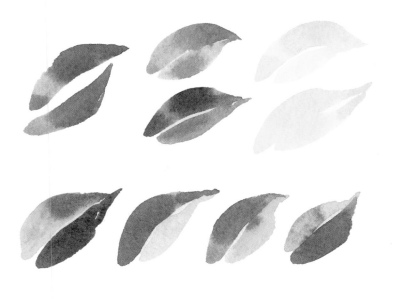

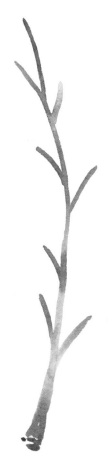

LEAF FORMS

Mix a yellow and a green. Practise leaf forms using just one colour and paint the leaves with two parallel strokes. To paint the first leaf half, start by applying medium pressure on the brush, then press down harder to make a thicker line, and as you finish the stroke, release the pressure again to end with a hairline stroke. Add the second leaf part by painting a mirrored parallel stroke in the same manner. To combine the two parts to create a leaf, paint the two parallel strokes very close to each other but leave a tiny gap between them to imitate highlights. Now practise double-coloured leaves. Paint the first stroke in yellow and the second one green, and vice versa.

STEP 01

Sketch the branch using outline 08 on page 229. Paint the stem green.

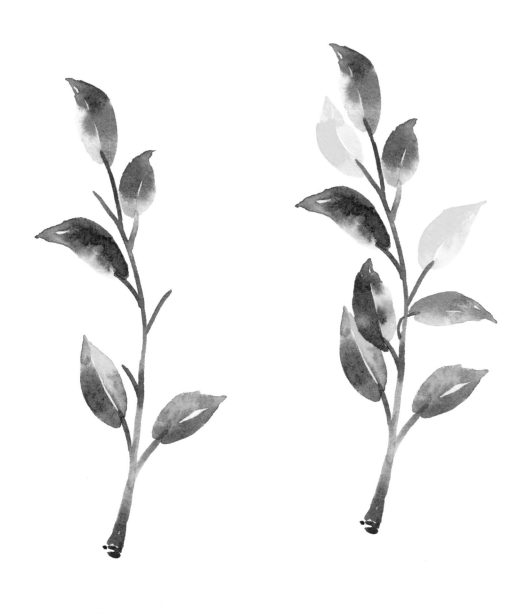

STEP 02

Add the first double-coloured leaves at the end of the leaf stalks.

STEP 03

Add the remaining leaves to make the branch fuller. If you like, introduce a few single-coloured leaves to make the composition less predictable.

Project 12

Avocado

I must admit, I love
painting avocados even
more than I love eating
them. The fruit's rounded
shape lends itself so well to
watercolour brushstrokes.
I simply cannot get
enough of this one.

STEP 01

Sketch the avocado shape using outline 09 on page 230. Mix green with a touch of yellow to obtain a light green. Apply a generous amount of water to your brush and fill the shape with the green mix, leaving the avocado stone area empty. Use more saturated pigment towards the edge of the shape and dilute the mix with more water as you move towards the centre, to create dimension. Let dry.

STEP 02

Using a smaller brush, apply a thicker, dark shade of green to the outline of the shape to imitate avocado skin. The less perfect it is, the better! Then switch to a dark brown mix and paint the tiny stem at the top.

STEP 03

Mix a rich, brown, earthy colour
for the avocado stone. Paint it in a
circular motion, filling in the empty
space you left in Step 1. Try not to
cover the entire shape with a layer
of paint – leave some empty areas
on the stone to imitate highlights.
Concentrate the darkest brown at the
edges of the stone, diluting the paint
slightly in the middle of the shape to
vary the intensity of the colour.

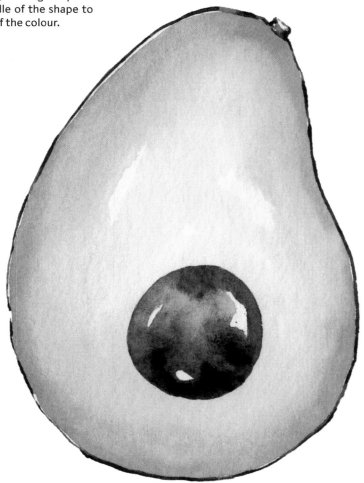

Project 13

Sailing Boat

Boats are dreamy and lend themselves well to quick watercolour sketches. Think of it as creative escapism! The exercise is monochromatic, so choose your favourite colour (it doesn't have to be red).

STEP 01

Sketch the boat using outline 10 on page 230. Mix one rich colour; I chose red. Start by painting a vertical line to create the mast with a flag at the top.

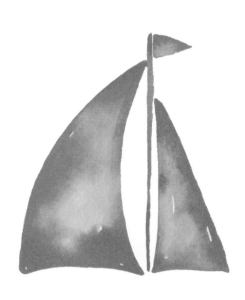

STEP 02

Paint the sails. Make sure you vary the amount of water you are applying within these shapes, so there is variation in tonal intensity within them.

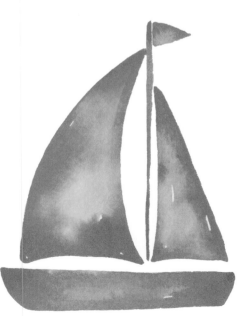

STEP 03

Paint the hull of the boat in the same way that you painted the sails.

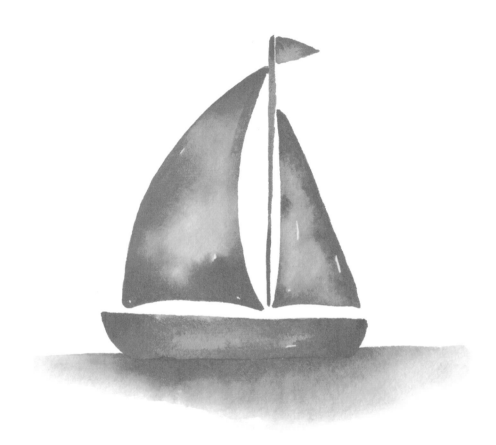

STEP 04

To paint the sea, apply a clear layer of water below the boat and drop some of the red paint on top, directly below the boat's hull, so you achieve the wet-on-wet effect of the pigment merging with the water and creating a gradient.

Project 14

Figure Shapes

People are perhaps one of the most difficult subjects to paint. Here is an easy trick for sketching figurative silhouettes which is approachable, fun and can complement a landscape scene nicely.

STEP 01

Sketch the figures using outline 11 on page 230. Mix a colour of your choice. Make a few strokes shaped like carrots – thicker at the top, narrower at the bottom – which will serve as the figures' silhouettes. You can make them plain like the first one; place two next to each other; add two legs to the 'carrot'; or experiment with bent knees and arms. The looser your strokes are, the better!

STEP 02

Using the same colour, add the heads. Make circular shapes above the carrot shapes – you can either leave an empty space between them to merely suggest the neckline, or feel free to connect the circles with the body.

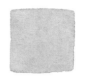

Project 15

Radishes

Radishes have sentimental value for me, as they bring back memories of summer holidays spent in my grandparents' garden when I was a child. They are equally lovely to eat and to paint!

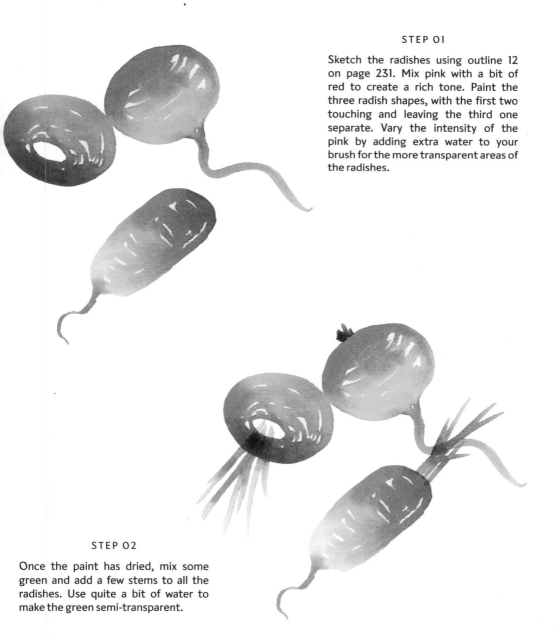

STEP 01

Sketch the radishes using outline 12 on page 231. Mix pink with a bit of red to create a rich tone. Paint the three radish shapes, with the first two touching and leaving the third one separate. Vary the intensity of the pink by adding extra water to your brush for the more transparent areas of the radishes.

STEP 02

Once the paint has dried, mix some green and add a few stems to all the radishes. Use quite a bit of water to make the green semi-transparent.

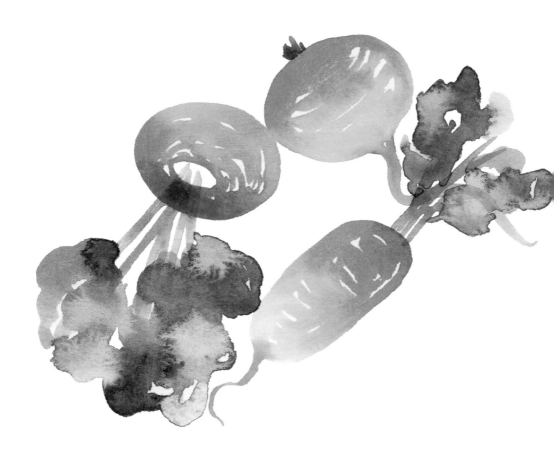

STEP 03

Load your brush with more green to paint the
leaves at the end of the stems. Use a generous
amount of water to create a good flow of paint
at first, then drop in darker green to vary the
contrast in the leaves. They don't have to be
perfect – the less rigid, the more natural the look.

Project 16

Aubergine

Aubergines or eggplants – whatever you choose to call them, they are a joy to paint in watercolour. The oblique purple shape stands in rich contrast to the light green stem, which makes the illustration pop.

STEP 01

Before painting the aubergine shape, practise the technique on a smaller area. Using the wet-on-wet method, apply a thin layer of water and then drop a saturated, dark mix of purple onto it to see the blooming effects. Experiment with various shapes to enhance your muscle memory.

STEP 02

Using outline 13 on page 230, sketch the aubergine lightly with a pencil. Then, using wet-on-wet, cover the entire shape of the aubergine (except for the green stem) with clear water and proceed to drop a saturated mix of purple onto the whole area. Add more pigment on the top, bottom and sides, and less pigment in the middle of the shape to preserve the highlights. Let dry.

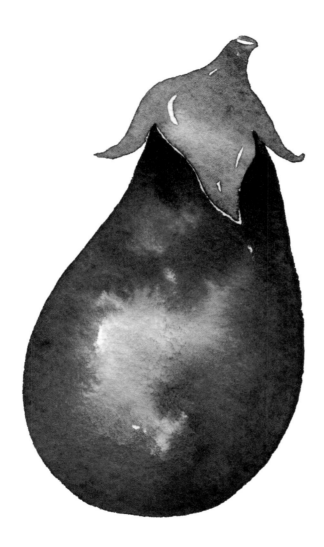

STEP 03

Using a rich mix of green with a touch of yellow, paint the stem. Try to keep the middle of the stem lighter in colour and its edges darker, to create a sense of dimension.

Project 17

Blood Orange

Citrus fruit is equally refreshing when eaten as it is when painted in watercolour. A blood orange is a top-tier subject due to the variety of vibrant colour you can pack into its segments.

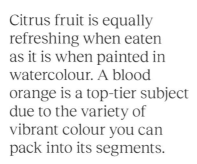

LEAVES

Mix green with a little yellow and practise leaf forms. The simplest leaves are made up of two parallel curved strokes. Paint one stroke with a generous amount of green, then dilute the paint with some extra water to make a lighter shade of green and add a parallel stroke. Let the strokes touch for a merging effect but try to leave tiny, thin gaps between them to imitate highlights.

CITRUS SECTIONS

Prepare a few different colours: red, magenta, orange, purple and yellow. Now practise painting individual orange segments to develop muscle memory. Each segment of a blood orange will be a slightly different shade, so play around with various colour combinations, leaving thin gaps in the segments to preserve the highlights.

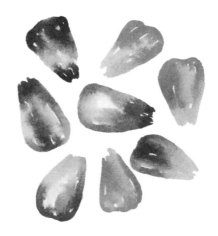

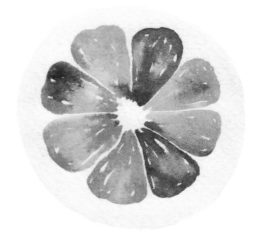

STEP 01

Using outline 14 on page 231, sketch the circle lightly – pencil lines will show underneath a layer of watercolour, so try to make them as subtle as possible. Using a lot of water, mix a pale shade of yellow and apply to the entire circle, making the edges more saturated than the middle. Let dry.

STEP 02

Lightly sketch the orange segments on top of the yellow circle, as shown. Paint the segments you practised at the beginning. Let dry.

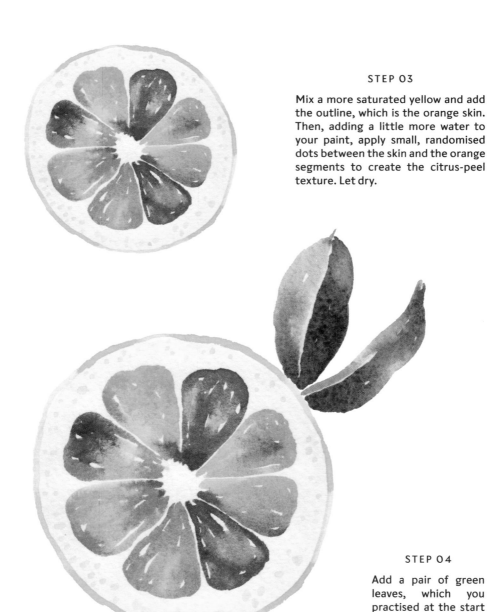

STEP 03

Mix a more saturated yellow and add the outline, which is the orange skin. Then, adding a little more water to your paint, apply small, randomised dots between the skin and the orange segments to create the citrus-peel texture. Let dry.

STEP 04

Add a pair of green leaves, which you practised at the start of the project.

Project 18

Seaweed

Perhaps it is the nature of watercolour - a water-based medium - that lends itself so well to painting algae and other sea forms. Try this simple seaweed illustration to understand what I mean!

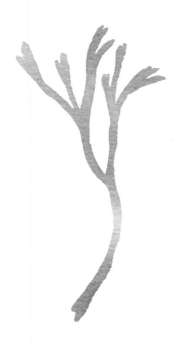

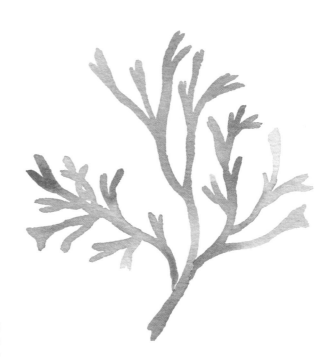

STEP 01

Sketch the seaweed using outline 15 on page 231. Mix an earthy green by combining green pigment with a touch of brown and yellow. Paint the first branch using the earthy tone.

STEP 02

Add the remaining branches using the same colour. Try to make some parts lighter in colour than others by varying the amount of water you are applying to your brush.

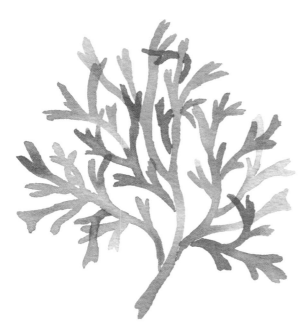

STEP 03

Add the last branches and smaller fronds. To make the composition more dynamic, feel free to overlap some of the seaweed fronds with others.

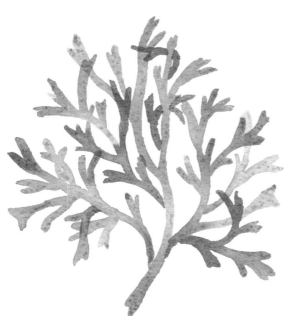

STEP 04

Using the earthy green, paint irregular dots all over the seaweed to create some texture.

Project 19

Watermelon

It doesn't get much better than the combination of watermelon and watercolour! This summery, juicy fruit thrives on the medium's transparency, and the contrasting pink and green work together beautifully.

STEP 01

Sketch the fruit using outline 16 on page 231 and mix a red with a touch of pink. Cover the shape of the watermelon with this pinkish-red, making sure that the top of the fruit has the richest tone and using more water to dilute the colour as you move towards the edges, until the red is nearly transparent. Leave some empty gaps within the shape for seeds and highlights.

STEP 02

Mix a very light yellow and a deep, rich green. Apply a layer of the pale yellow at the curved edge of the watermelon where the red has turned nearly transparent. Quickly load your brush with the green.

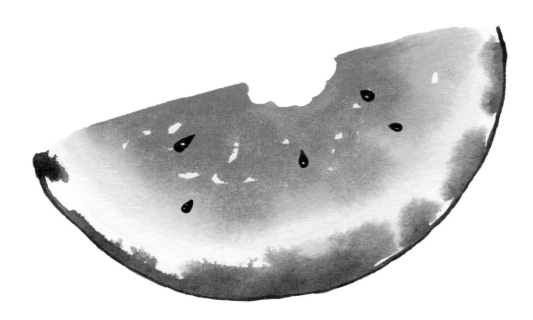

STEP 03

While the layer of pale yellow is still wet, apply a line of green at the bottom edge so that it blends with the yellow in a wet-on-wet style. Leave to dry, mix some black paint and add watermelon seeds. When the green has dried, apply a single thin brushstroke of deep green around the bottom edge of the fruit to represent the skin.

Project 20

Mushroom

The thought of mushrooms immediately brings a memory of a rainy autumn forest to my mind. Painting them in watercolour is a pleasure, and easy if you follow the process step by step.

STEP 01

Sketch the mushroom using outline 18 on page 232. Mix a peaty, warm brown and fill in the mushroom cap with the colour. Try to vary the intensity of colour within the shape, making the sides darker than the middle and leaving some empty gaps to create highlights. Let dry.

STEP 02

Mix a very light brown and add the thin section of gills visible beneath the mushroom cap.

STEP 03

Using a light brown with a touch of yellow, paint the mushroom stalk. Make the top (below the cap) slightly darker than the bottom. Let dry.

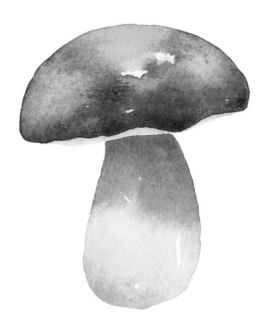

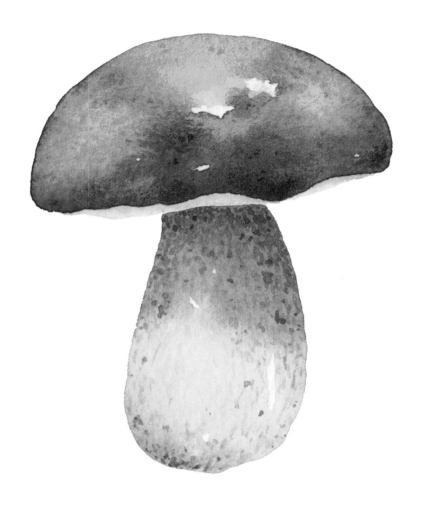

STEP 04

Add some texture to the mushroom, especially the stalk, using small, irregular brushstrokes in the shape of dots and thin, short lines in a darker brown – mix in a little extra black to the brown you used in Step 1.

Project 21

Cherries

This quick cherry
illustration pops right
off the page and brings
back memories of
long summer days!

STEP 01

Draw the cherries using outline 17 on page 231.
Mix a few similar cherry colours: red, some
purple, orange, pink. Fill in the two cherry shapes,
switching between various shades so that the fruit
is multicoloured. The edges of the cherries should
be darker than the centre; leave some gaps to
imitate highlights.

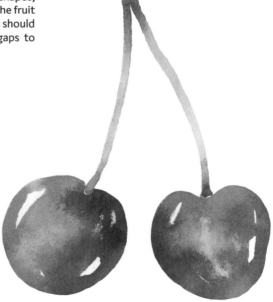

STEP 02

Mix a little green with a bit of brown
and paint the thin cherry stems.

STEP 03

Mix a light brown and rich green. First, paint a tiny brown stalk at the top of the cherry stems. Now switch to green and add a leaf at the top of the stem using two parallel strokes. One side of the leaf should be a dark green. Paint the second side of the leaf using more water for a lighter shade of green.

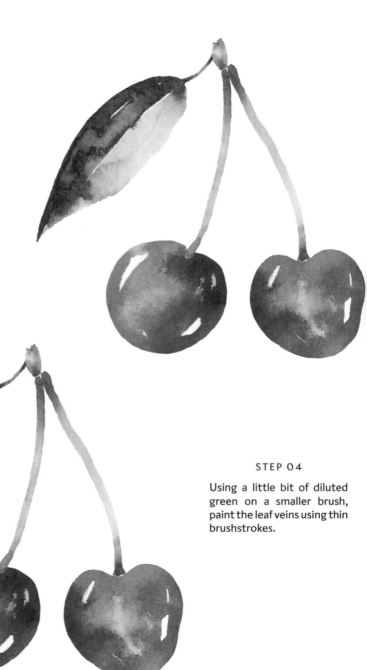

STEP 04

Using a little bit of diluted green on a smaller brush, paint the leaf veins using thin brushstrokes.

Project 22

Simple Landscape

Landscapes can be tricky to paint, and one great way to make them more accessible is to simplify as much as possible. Try this easy, whimsical scene that only requires three colours!

STEP 01

Mix a sky blue using a good amount of both pigment and water so the paint has a good flow. Apply the blue from left to right, and vice versa, in horizontal strokes, starting at the top of the sky. The top should be the most saturated blue. As you move down towards the horizon, pick up more and more water to dilute the colour and create a gradient.

STEP 02

Mix a warm grassy green. We will repeat the gradient method from Step 1 but in reverse, from very light green at the horizon to saturated at the bottom of the painting. You can start by applying a stroke of clean water at the horizon line and adding the green pigment gradually, or alternatively start with the green at the bottom of the grass and add more water to your brush as you move up towards the horizon. Let dry.

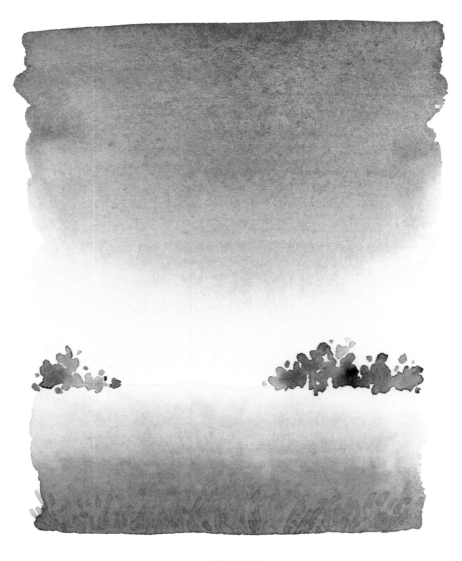

STEP 03

Mix a little darker green and make irregular dabbing strokes
to suggest trees on the horizon line. Add more pigment to
make a stroke darker, then apply more water to paint a few
further strokes next to it to create dimension. Then dilute
the pigment a little and add a few short line strokes at the
bottom of the green gradient to illustrate grass. Only paint
the blades there to indicate perspective.

Project 23

Green Tree

The key to painting a lively looking tree in watercolour is to keep it simple and make loose brushstrokes. Vary the saturation of the green to make the foliage pop off the page.

STEP 01

Sketch the tree using outline 20 on page 232 and mix an earthy brown. Paint the tree trunk, making sure that the edges are a darker brown – when you reach the middle of the trunk, dilute the brown with some water to paint it a lighter shade.

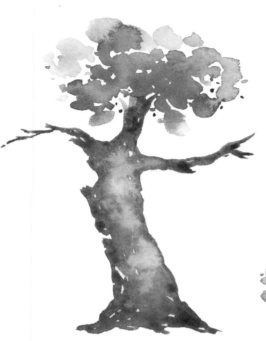

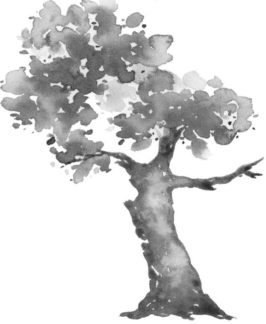

STEP 02

Mix a generous amount of grassy green. Start painting the tree canopy by making rounded, irregular strokes, pressing quite hard with the brush. While the initial strokes are still wet, vary the amount of pigment and water you are applying. Keep some parts of the canopy a more intense green and others a lighter shade to create contrast and vibrancy.

STEP 03

Continue adding more strokes as in Step 2, expanding the treetop. It is important to maintain some empty gaps between strokes to imitate light shining through the foliage.

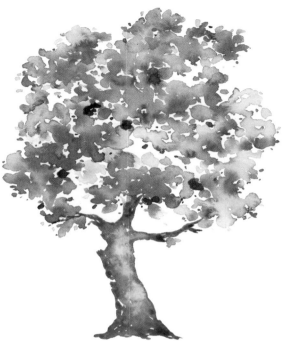

STEP 04

Finish painting the foliage by repeating the method from Step 3 until the treetop is full.

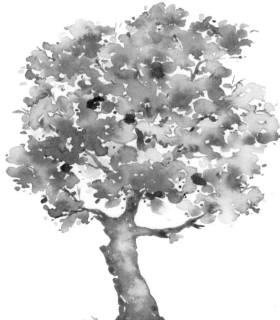

STEP 05

Go back to the brown and paint a few branches in between the green leaves of the tree. Then mix the brown with a touch of the green you used for the leaves to obtain a dull grassy shade. Add short parallel strokes at the bottom of the tree.

Project 24

Pears

Pears are one of the most delightful fruits to paint loosely in watercolour. Their plump shape works well for rounded brushstrokes and the skin is rich in pigment, which simply demands to be illustrated!

STEP 01

Sketch the pears using outline 21 on page 232. Mix a watered-down yellow, plus red and orange. Start by covering the left pear with a layer of the pale yellow, using a decent amount of water. While it is still wet, quickly pick up orange paint and start painting the second pear. Apply orange, starting at the outline, and touch the edge of the first pear to achieve a wet-on-wet blooming effect. Add some water to your brush to make the second pear lighter in the middle. Now pick up some red to finish off the shape. Let dry.

STEP 02

Using a very diluted orange, paint delicate lines on the left pear to outline the core of the fruit. Make your brushstrokes as delicate as you can.

STEP 03

Mix a brown colour. Using a smaller brush, paint the stems at the top of the pears, two sets of 'hairs' at the bottom, and a couple of pips inside the core lines of the left pear. Make sure the pips have tiny gaps inside to indicate highlights.

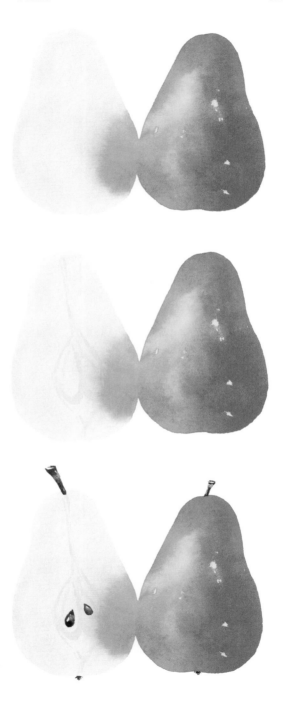

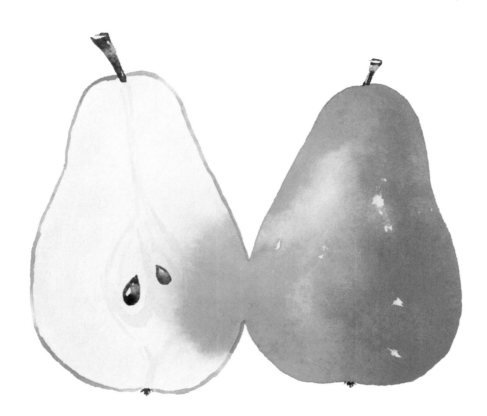

STEP 04

Go back to the orange and red and, using a thin brushstroke,
add an outline to the left pear to represent the skin. To make
it double-coloured, start the stroke with one colour, clean
the brush off a bit and load up with a second to continue the
stroke. Repeat until you have painted the entire skin.

Project 25

Banana Leaf

If you are looking for a different take on green foliage, try painting this folded banana leaf. The two shades of green create a bold contrast and make for a striking composition.

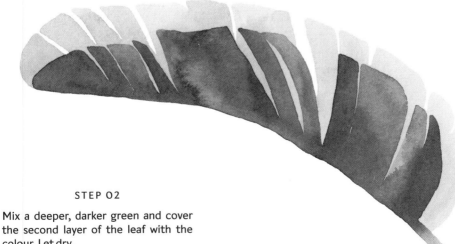

STEP 01

Sketch the leaf using outline 22 on page 233. Mix a light green and cover the entire shape in an even layer of the colour. Let dry.

STEP 02

Mix a deeper, darker green and cover the second layer of the leaf with the colour. Let dry.

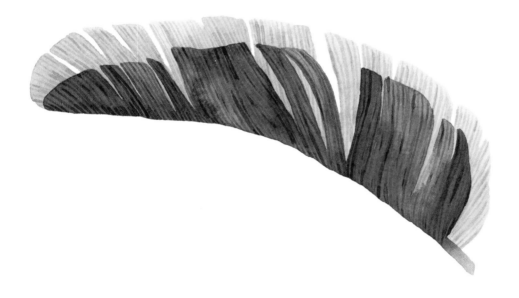

STEP 03

Add texture to the leaves by applying thin parallel lines on both sides. Use the light green from Step 1 for the lines on the background leaf. Use the darker green from Step 2 for the texture on the foreground one.

Project 26

Banana

A humble banana is
nutritious for your body
and also happens to be
a fun illustration subject.
You don't need many
colours in your palette
to brighten up the page
with this sunny fruit!

STEP 01

Sketch the banana using outline 23 on page 233. Mix a sunny yellow and cover the entire silhouette of the banana with the colour, paying attention to changing the saturation of the pigment within the shape. Apply richer tones at the bottom, using more water to dilute the paint at the top of the banana and at the stem. Let dry.

STEP 02

Mix a dark brown, almost black, colour. Using small brushstrokes, add the dark part on top of the banana stem as well as at the other end.

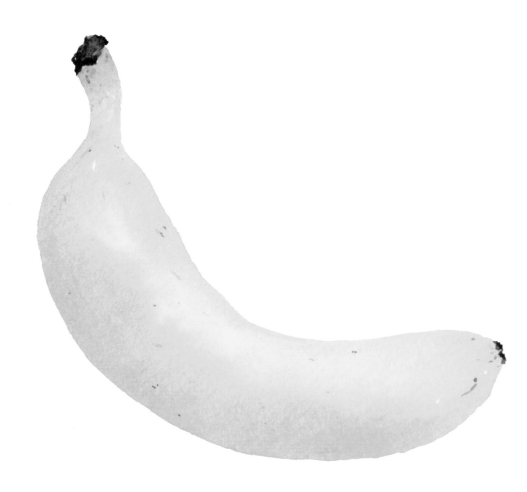

STEP 03

Mix a very pale green and apply a thin layer to the stem to make the banana look more natural. Switch to a pale brown and add irregular dots and little lines around the banana to create texture.

Project 27

Grapefruit

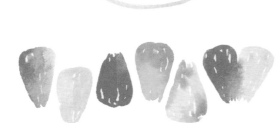

The contrast between the red and blue here is what steals my heart. Painting grapefruit on a blue 'tablecloth' makes me think of long summer days in southern Europe.

STEP 01

Mix a warm yellow and a red. Practise citrus skin by painting a curved line with the yellow, then applying a layer of clear water inside it to create a gradient. Switch to red and practise citrus sections. Start with a few individual ones, making triangular shapes and leaving some gaps inside to create highlights. Then paint a few more sections, this time merging them at the sides.

STEP 02

Sketch the grapefruit using outline 24 on page 233. Load your brush with warm yellow and paint the outlines of the grapefruit as practised in Step 1. Let dry.

STEP 03

Fill in the shapes by painting the citrus sections with red paint. Vary the saturation of the red by diluting the paint with water, then grabbing a bit more pigment, and moving back and forth to create contrast in the sections. Let dry.

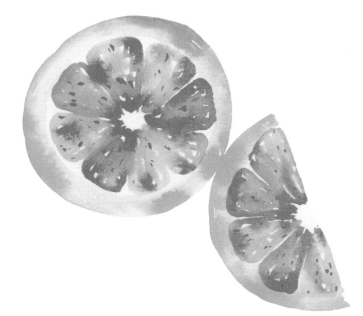

STEP 04

Using the same red, add a few irregular dots and marks to the citrus sections to create texture.

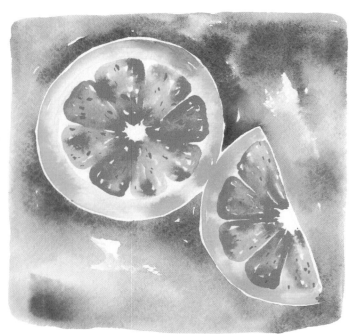

STEP 05

Mix a deep blue. Using a lot of water, start applying the blue to the background, avoiding touching the grapefruit edges too much and leaving some gaps so that the white of the paper shows through. Vary the amount of water you apply to make the blue paler, and add more pigment to make it stronger, continuing in this rhythm until the background is complete.

Project 28

Festive Holly

Use this guide to paint handmade festive cards or gift tags, and I can assure you your loved ones will appreciate the personal touch.

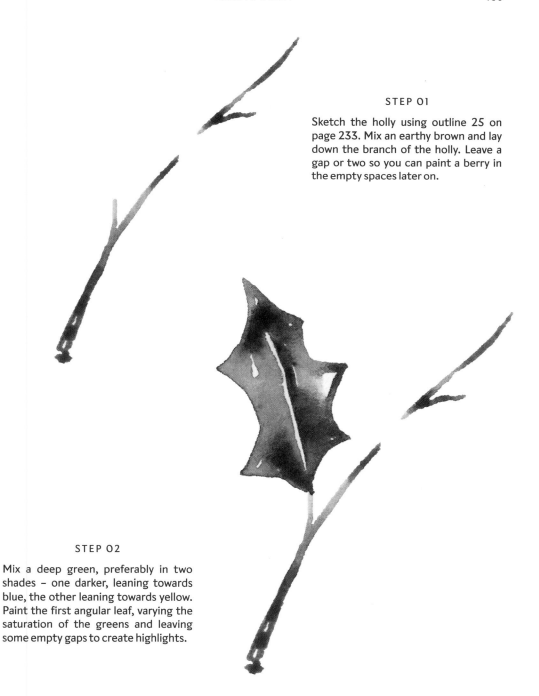

STEP 01

Sketch the holly using outline 25 on page 233. Mix an earthy brown and lay down the branch of the holly. Leave a gap or two so you can paint a berry in the empty spaces later on.

STEP 02

Mix a deep green, preferably in two shades – one darker, leaning towards blue, the other leaning towards yellow. Paint the first angular leaf, varying the saturation of the greens and leaving some empty gaps to create highlights.

STEP 03

Paint two more angular leaves in the same way. Let dry.

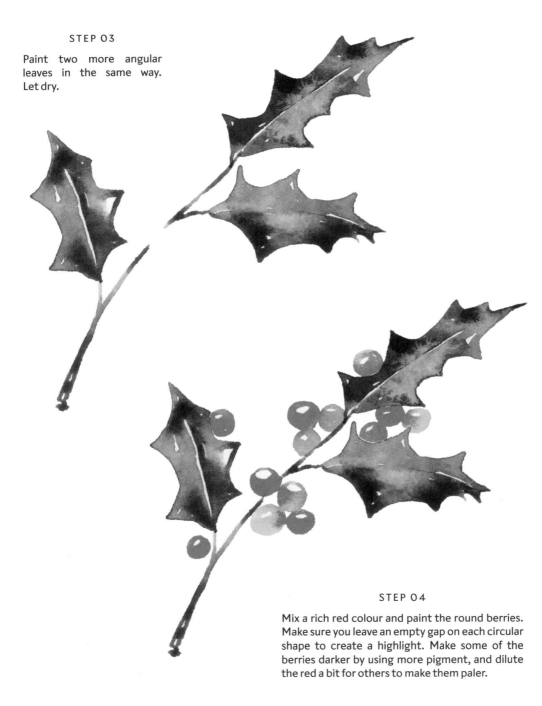

STEP 04

Mix a rich red colour and paint the round berries. Make sure you leave an empty gap on each circular shape to create a highlight. Make some of the berries darker by using more pigment, and dilute the red a bit for others to make them paler.

Project 29

Snowflake

Try painting this icy blue snowflake to experiment with geometric shapes. In nature, snowflakes are one of the most perfect formations, but don't worry too much about perfect angles here.

STEP 01

Sketch the snowflake using outline 26 on page 234. Mix a couple of blue shades, a deep blue and a lighter sky blue. Use more water to dilute the deep blue to create different values. Start painting the first 'arm' of the snowflake by applying dark blue at the outer edge, and dilute the pigment as you move forwards.

STEP 02

Add two further arms, changing the colour placement in each one. For example, this time you can start painting with a diluted blue and add a darker shade as you move on.

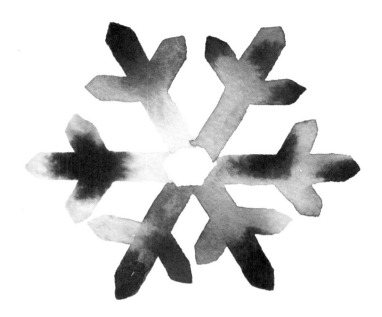

STEP 03

Add the remaining arms in a similar manner.

STEP 04

Add in little 'diamonds' between each snowflake arm to create a fuller and more interesting composition.

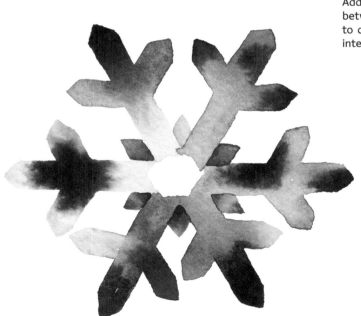

Project 30

Snowy Tree

This is my favourite way to paint snow-covered trees, a topic I return to every winter. The trick to illustrating snow in watercolour is to use plenty of water and as little pigment as possible.

PRACTICE

First, practise the wet-on-wet technique. Mix a very pale grey colour (using black and a bit of blue with a lot of water) and a deep green. Load your brush with the watery mix of pale grey and put a layer on dry paper. Quickly load the brush with the green and apply the pigment so it touches the edges of the grey shape. Apply the green in irregular dabbing brushstrokes to achieve branch-like shapes beneath the grey.

STEP 01

Sketch the pine tree using outline 27 on page 234. Start with green. Paint a single vertical line at the top of the tree, then expand into more horizontal branch-like shapes as you move down. Once the crown of the tree is expanded and while the green is still wet, quickly wash off your brush and switch back to pale grey. Apply it by touching the edges of the green (a reverse of Step 1) to create a layer of snow.

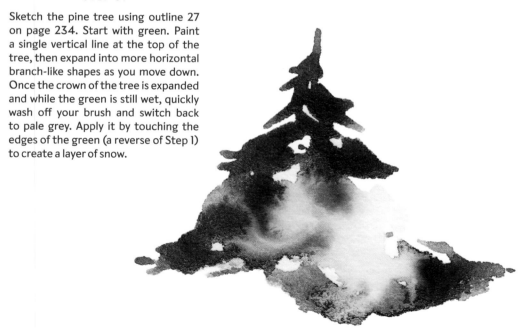

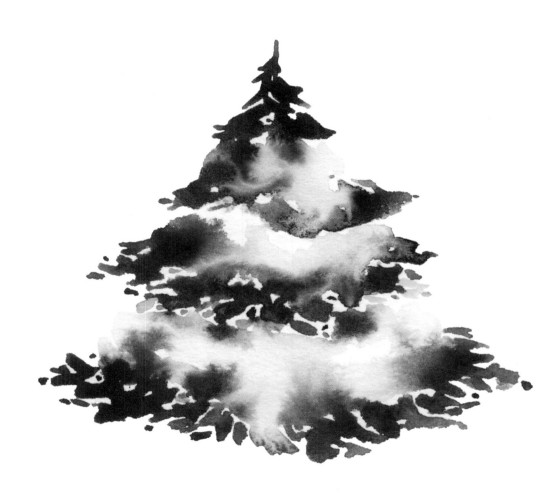

STEP 02

Continue painting the tree in the same rhythm to fill in the entire sketch. I like to place the pale grey 'snow' on top of each layer of the green branches.

Project 31

Butterfly

A dreamy and colourful butterfly to lighten up your day if you are looking for a creative boost. Feel free to paint it with your favourite colours.

STEP 01

Sketch the butterfly using outline 28 on page 147. Paint the first part of the butterfly wing. Start with red at the top, adding some more water to dilute the colour as you move towards the middle of the wing. Then pick up a bit more red on your brush for the middle. Switch to yellow for the lower part of the wing, deepening the intensity towards the bottom.

STEP 02

Paint the other wing using the same process as in Step 1. Try to vary the saturation of the paint to create dimension by diluting it until it is more transparent and then adding more pigment again to add more punch. Follow back and forth in this rhythm.

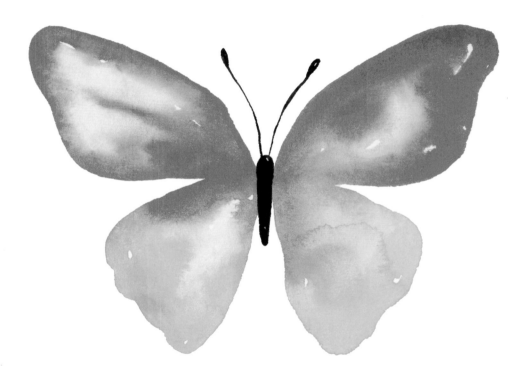

STEP 03

Mix some black and paint the body and
antennae of the butterfly.

Project 32

Ice Cream Cone

Someone once told me that
an ice cream a day keeps
the stress away. Eating one
every day is perhaps not
something I would choose
to do, but who says we
can't paint one instead?

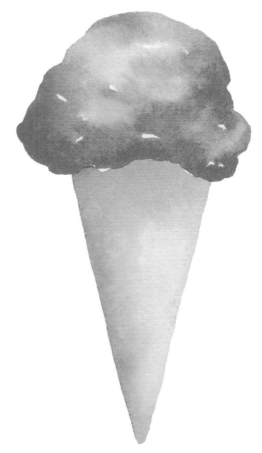

STEP 01

Sketch the ice cream using outline 29 on page 234. Mix the waffle colour using a warm yellow with a bit of brown. Paint the cone first, covering the entire shape with the mix. Give one side of the cone a darker value and dilute the colour on your brush as you move towards the other side. Let dry.

STEP 02

Mix a vibrant ice cream colour – I opted for raspberry, but you can paint whatever flavour you like best! Apply a generous amount of water and pigment to your brush so that you have a good flow. Control the saturation of the paint; the top and middle parts of the ice cream should be more transparent than the edges and the bottom.

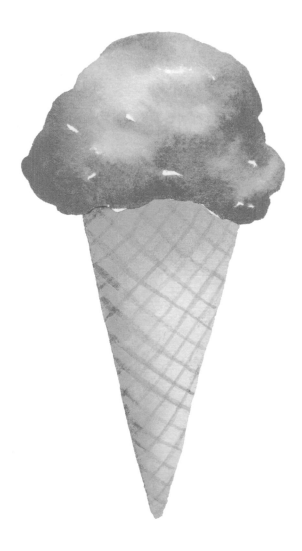

STEP 03

Go back to the waffle colour, this time mixing in a touch more brown. Then dilute the colour with extra water so that the pigment isn't too dark. Switch to a smaller brush and add the parallel lines in rows in both directions to illustrate the cone's texture.

Project 33

Kiwi Fruit

Kiwi fruit may look tricky to paint, but they aren't if you break the process down into steps. It's one of my favourite subjects to sketch when I've run out of ideas.

STEP 01

Sketch the kiwis using outline 30 on page 235 and mix some light green. Paint the oval and half-moon shapes, connecting them at the sides. Make sure you give the edges a stronger value of green and dilute the paint as you move towards the centre of the fruit. Let dry.

STEP 02

Mix an earthy brown. Paint the remaining oval kiwi shape and add kiwi skin outlines to the green shapes you painted in Step 1. Let dry.

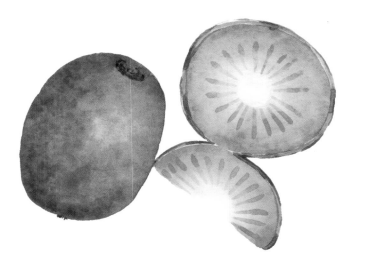

STEP 03

Using a diluted green, add straight lines to the centre of the kiwi sections to imitate the fruit's particular texture. Mix a little dark brown and add the subtle details at the top and bottom of the whole kiwi.

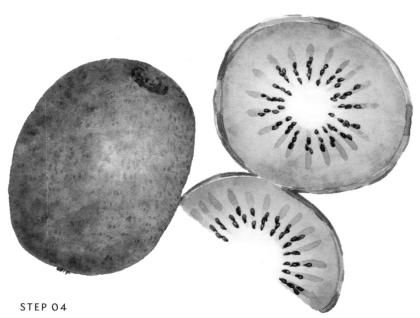

STEP 04

Switch to a small brush. Using a very light brown, apply tiny brushstrokes to the whole kiwi to imitate the fruit's hair. Mix black and paint the tiny kiwi seeds at irregular intervals on top of the straight lines you painted in Step 3.

Project 34

Anemone

Anemones are charming
flowers with soft petals
and a strong black centre,
which make for a striking
botanical subject. They
come in a variety of
colours so feel free to
experiment more!

STEP 01

Sketch the flower using outline 34 on page 235 and mix a deep purple. Start with two opposite petals. Every petal will be painted in the same way. Load your brush with a watered-down pale purple and cover the entire petal with a layer of nearly transparent colour. While it is still wet, dry your brush a little bit and load it up with some more purple. Drop a little pigment on the inside of the petal. Let dry.

STEP 02

Add two more petals opposite each other in the same manner. You can overlap the sides of the new petals with the ones painted in Step 1 to create a delicate layering effect. Let dry.

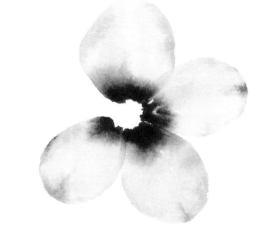

STEP 03

Add the final petal in the same manner.

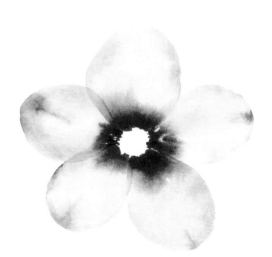

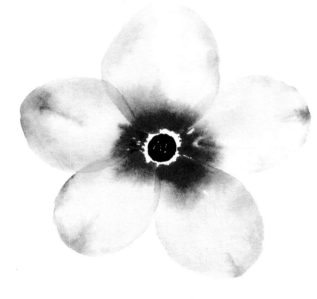

STEP 04

Mix a dense black. Paint a circle shape in the empty space between the petals, making sure you leave a few tiny empty gaps within the black circle.

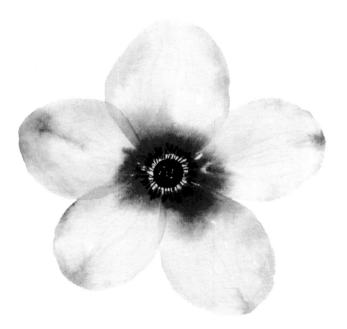

STEP 05

Stay with the same black and, using a smaller brush, paint a series of thin, short lines, stemming from the black circle. Then add little dots at the end of the lines to create flower stamens.

Project 35

Flamingo

Some days you need to lift
your mood with a vibrant,
tropical illustration like
this lovable flamingo.
Imagine yourself strolling
along a beach in the
Caribbean, and get lost
in the painting process.

STEP 01

Sketch out the flamingo using outline
31 on page 235. Mix a vibrant pink and
lay down a layer of the colour on the
bird's head and body. Dilute the pink
with water as you reach the middle and
top of the flamingo's back and the tip of
the head, keeping the neck and the tail
a stronger value of pink.

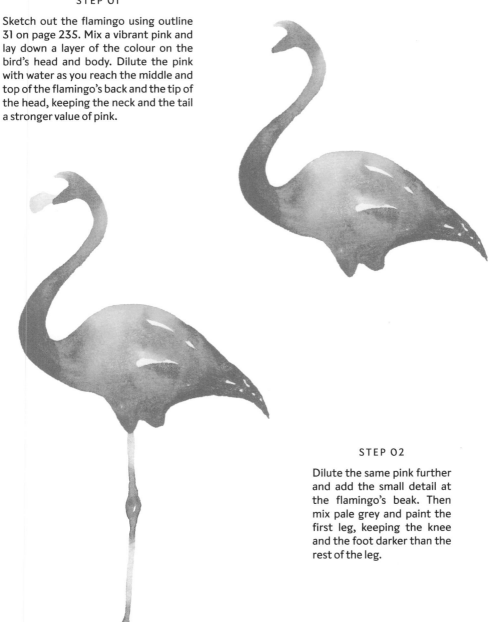

STEP 02

Dilute the same pink further
and add the small detail at
the flamingo's beak. Then
mix pale grey and paint the
first leg, keeping the knee
and the foot darker than the
rest of the leg.

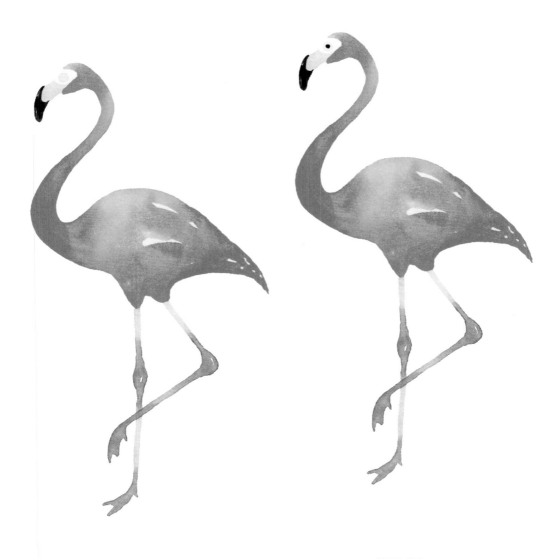

STEP 03

Using the same grey, add the second leg in the same way. Then clean your brush, mix some light yellow and paint a circle on the bird's head where the eye will be. Now, mix some black and paint the beak, leaving empty gaps to imitate highlights.

STEP 04

Once the yellow circle has dried, use the same black to paint a small dot to create the bird's eye.

Project 36

Cats

Painting animals can
be easy if you focus on
silhouettes and forget the
details! Paint in a steady
but fast pace without many
breaks until the end to
prevent the paper from
drying in the process.

STEP 01

Sketch the single cat silhouette using outline 32 on page 234. Mix one paint shade of your choice with a lot of water. Start filling in the shape of the cat with this colour. Adjust the intensity of the paint by either adding or removing pigment from your brush, and adding or removing excess water. Going back and forth in this rhythm will help you achieve varied contrasts and highlights.

STEP 02

Continue painting in the same manner to extend the shape to the cat's torso, front legs and nearest back leg.

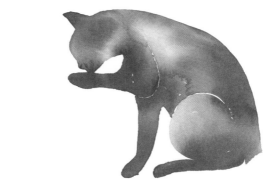

STEP 03

Add the cat's tail and the lower part of the second leg just behind the first.

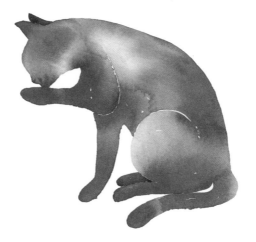

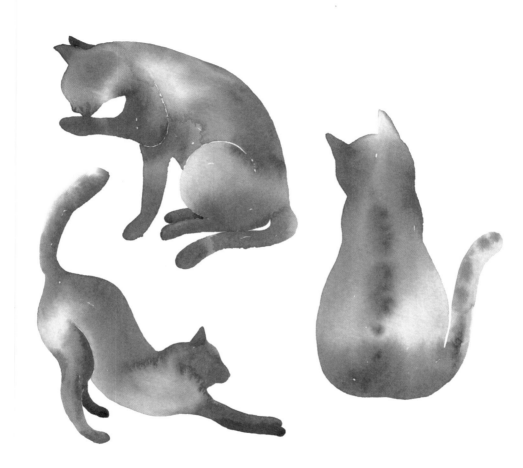

STEP 04

Using outline 32 on page 234, sketch the other two cat silhouettes and paint them in the same manner. Then experiment with your own cat sketches if you like!

Project 37

Peaches

I could never resist painting at least one set of peaches in every sketchbook I have ever owned. The wet-on-wet method is perfect for the punch of colour in the middle of the fruit.

STEP 01

Sketch the peaches using outline 33 on page 235. Mix a bright sunny yellow and fill in the shapes, making sure they touch at the sides. Make the parts closer to the edges a more saturated yellow and dilute the paint towards the middle of the peaches, except the very centre of the whole peach, where you should leave an empty gap. Let dry. In the meantime, mix a deep red colour.

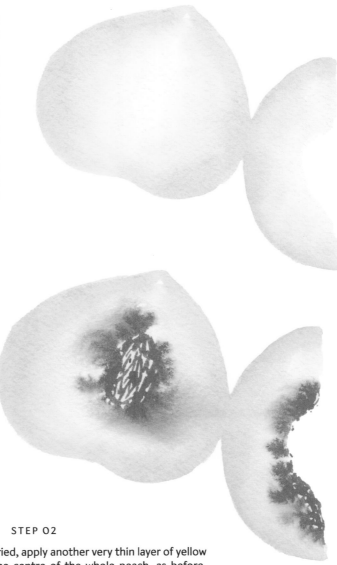

STEP 02

When the yellow layer has dried, apply another very thin layer of yellow on both peaches, except the centre of the whole peach, as before. While everything is still wet, pick up some deep red on your brush and with irregular brushstrokes, drop it on the edges of the middle parts of the peaches to achieve a wet-on-wet merging effect. Make the red strokes ragged to evoke the texture of the peach stone and the uneven fruit flesh. Let dry.

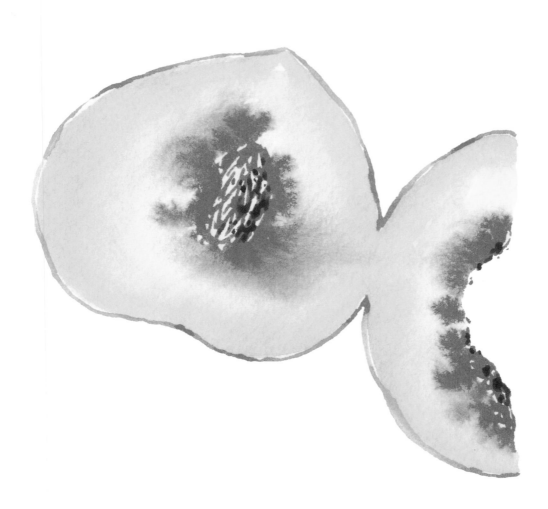

STEP 03

Using the same red, paint the skin around the edges of the peaches. Vary the amount of water you use for the skin to create variety in the red shade. Then add a tiny bit of green to the red (it is a complementary colour and will dull down red) and a little blue (it will darken the red further) to add tiny strokes to the middle of both peaches to add texture, contrast and imitate the stone.

Project 38

Hibiscus

One of the most iconic
tropical flowers, hibiscus
is a joy both to look at and
to paint. Tackle it petal
by petal and immerse
yourself in the vibrant,
dreamy colours.

STEP 01

Sketch the hibiscus using outline 35 on page 236. Mix a deep pink and paint the first petal. Start at the thin end by applying dense paint in irregular strokes, preserving gaps between them. As you move up the shape, gradually add more water to your brush to dilute the pink. The outer part of the petal should be lighter than the thin end.

STEP 02

Mix some red to go alongside the pink. Paint three more petals as you did in Step 1, introducing some red into the petals this time.

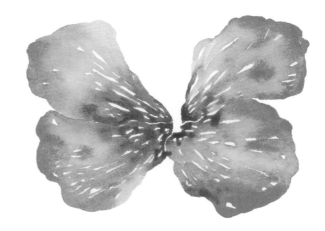

STEP 03

Paint the last petal in the same manner, this time leaving an empty gap for the pistil. Let dry.

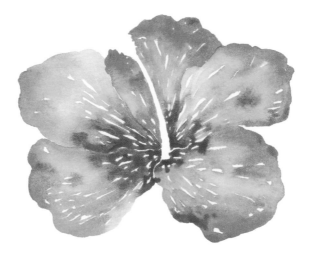

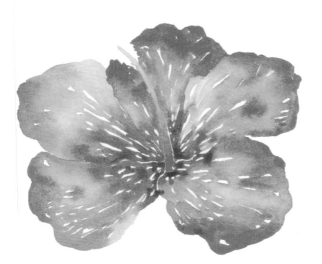

STEP 04

Mix yellow in your palette. Fill in the vertical gap to paint the pistil in the centre of the petals. Start at the bottom by applying some pink, then gradually add more yellow to your brush to transition to a full yellow at the top.

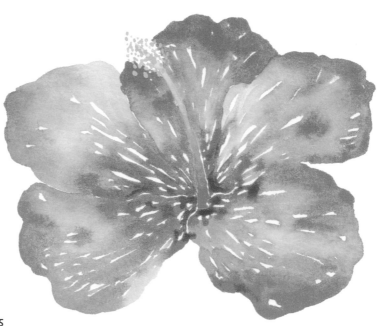

STEP 05

Using little water and a lot of dense yellow pigment on your brush, paint pollen at the end of the pistil by laying down dots of colour.

Project 39

Whale

Whales are some of the
largest creatures on Earth,
yet they seem to possess
a particularly serene aura.
Try this simple method to
paint one in watercolours!

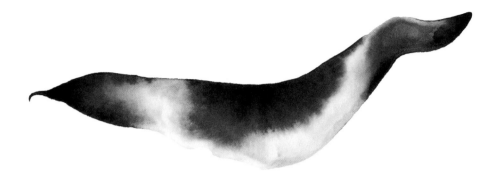

STEP 01

Using outline 44 on page 238, sketch the whale. Mix a deep shade of blue and then wash your brush completely so it is loaded with clean water. Cover the first part of the whale in a layer of water. Now, using the wet-on-wet method, drop some blue at certain points of the shape, but not the entire area. Let the pigments settle the way they wish.

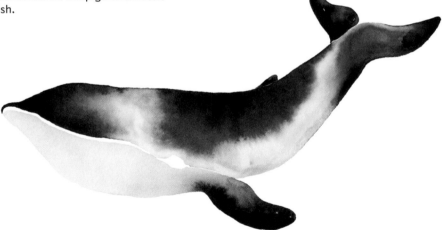

STEP 02

Stay with the dark blue and paint the two fins at the top. Then load your brush with more water to achieve a light blue mix. Cover the bottom part of the whale with a layer of the watery mix. Using wet-on-wet, grab the dark blue on your brush again and drop some paint onto the bottom fin. Let dry.

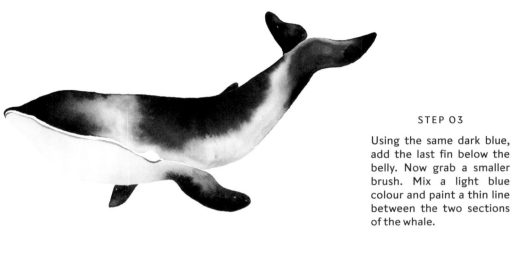

STEP 03

Using the same dark blue, add the last fin below the belly. Now grab a smaller brush. Mix a light blue colour and paint a thin line between the two sections of the whale.

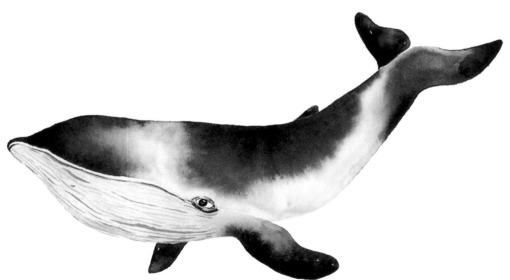

STEP 04

Stay with the light blue colour and the small brush to add irregular lines to the mouth and belly. Make some of the lines a bit darker to vary the contrast. Add some wrinkles around the eye, and at the end mix black and paint the eye. Make sure to leave empty gaps in the eye to create reflections.

Project 40

Pomegranate

Pomegranates are one of the most enchanting looking fruits in my opinion. I love their shape, the rich colours and unusual seed forms. The key to painting a juicy one is to mix vibrant reds!

STEP 01

Mix a few shades of red: a deep red, a purple-red and an orange-red. Practise painting the pomegranate seeds first to get the hang of the movements. Try making individual seeds by painting little circles with an empty gap in each one to preserve the highlights. Then paint a cluster of seeds that touch and merge with each other at the edges.

STEP 02

Sketch the pomegranate using outline 36 on page 237. Mix a pale yellow, a deep red and brown. Cover the entire pomegranate shape in the pale yellow, making the edges slightly more saturated than the middle.

STEP 03

While the light yellow base is still wet, quickly apply deep red to the outline of the pomegranate and deep brown at the top to create the 'crown'. Let dry.

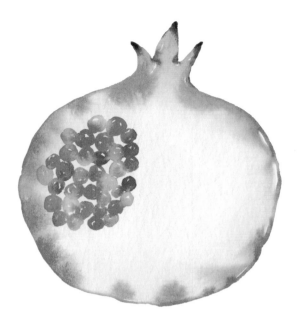

STEP 04

Start applying the clusters of seeds, as practised in Step 1.

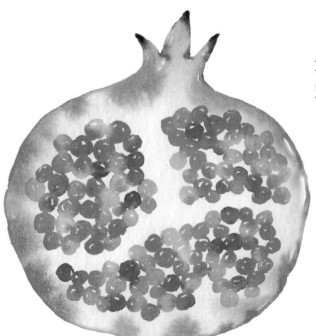

STEP 05

Add the remaining two clusters of pomegranate seeds to fill in the fruit.

Project 41

Robin

I have a soft spot for painting chubby birds. If you give me the choice, I will always say the rounder, the better! Robins are especially appealing because of their vibrant red-orange breasts.

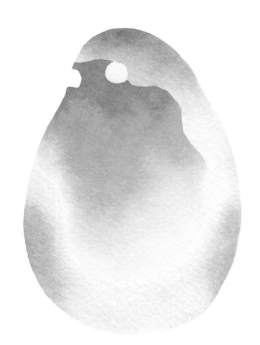

STEP 01

Sketch the robin using outline 37 on page 236. Mix a very diluted brown and paint the top of the head, diluting the colour even more as you extend along the bird's back, until nearly transparent.

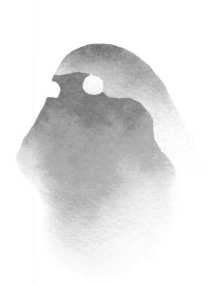

STEP 02

Mix a bright, saturated red-orange and start applying next to the diluted brown on the bird's head. Leave an empty space for the beak and the eye. As you move down the robin's breast, dilute the orange until it turns pale yellow. Clean your brush.

STEP 03

Go back to the pale brown you used in Step 1 and fill in the sides and underneath of the bird's body. Paint the edges a little darker, but overall keep the brown very diluted. Let dry.

STEP 04

Mix some black paint and, using a smaller brush, paint the tail. Try painting it in parallel strokes, leaving a few empty gaps between them.

STEP 05

Using the smaller brush and black paint, paint the remaining parts. For the beak, keep the top a more transparent black than the bottom, to create dimension. For the eye, keep the black dense but leave some empty gaps in the eye to illustrate reflections. Lastly, paint the two legs – dilute the black a little to make them dark grey.

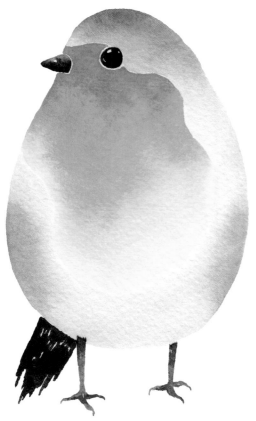

Project 42

Swiss Cheese Plant

The Swiss cheese plant, or *Monstera deliciosa*, is a charmer and one of my favourites to paint in watercolour. Filling the unusual leaf shape with rich, juicy greens always puts a huge smile on my face!

STEP 01

Sketch the cheese plant using outline 38 on page 237. Mix a few different shades of green: a mid-green, a bluish green and a yellowish green. Start painting the monstera, filling in the leaf sections one by one. Paint each section a slightly different shade of green.

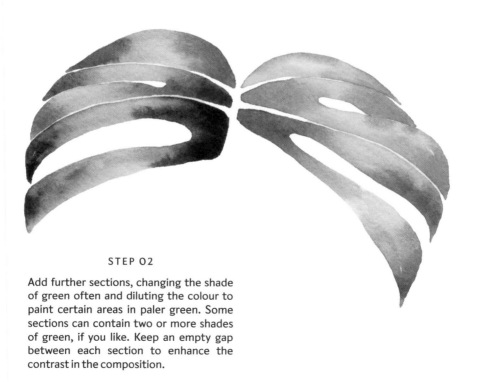

STEP 02

Add further sections, changing the shade of green often and diluting the colour to paint certain areas in paler green. Some sections can contain two or more shades of green, if you like. Keep an empty gap between each section to enhance the contrast in the composition.

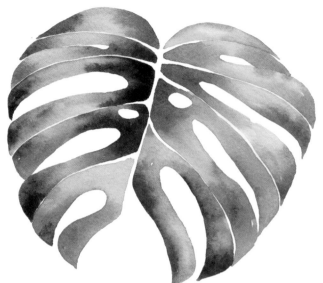

STEP 03

Continue in the same way. Don't worry about covering the sections thoroughly; in fact, leaving some irregular gaps between your brushstrokes will create a more intriguing look.

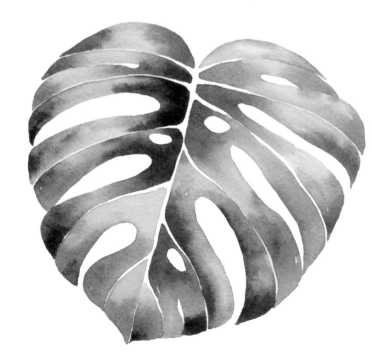

STEP 04

Finish off the last sections of the plant in the same rhythm.

Project 43

Sausage Dog

With its long torso, the dachshund makes a fantastic pet portrait subject. This dog's fur has a particular sheen to it, and watercolour is the perfect medium to show off its full charm.

STEP 01

Sketch the dog using outline 39 on page 236. Mix a generous amount of black. Start by applying a layer of clear water to half of the dog's silhouette, starting from the back legs. When the shape is covered in water, load your brush with black and drop it onto the wet surface, starting from the back legs, to achieve a wet-on-wet effect. Continue immediately to Step 2.

STEP 02

Load your brush with more water at this point to continue filling in the rest of the dog's silhouette. When the torso and front legs are covered with a layer of water, go back to the black and drop it onto the wet surface, starting at the front legs and neck. Try to make the legs and the belly darker than the top – to keep certain areas brighter, don't drop black directly near them.

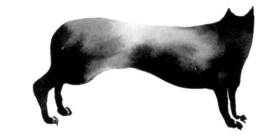

STEP 03

Continue painting with black to create the dog's face. Add some more water to your brush to make the dog's forehead a little more transparent, leaving an empty gap for the eye. Then paint the perky tail.

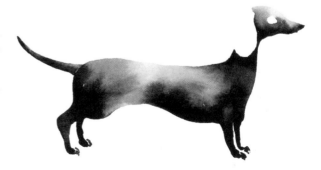

STEP 04

Add the dog's ear. Then dilute the black you've been using to mix a pale grey and paint the little nose. Let dry.

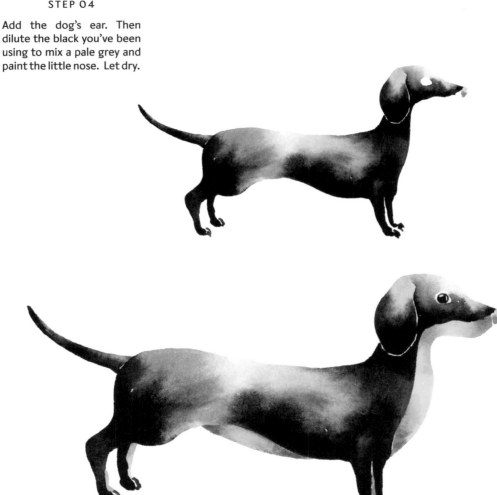

STEP 05

Mix a warm brownish yellow. Add strips of colour to the dog's legs, belly and the head and chest area. Then go back to the deep black and paint a circular eye in the empty space. It is important to leave small gaps in the eye in order to capture reflections.

Project 44

Apple

They say an apple a day keeps the doctor away. I concur but take it a step further – I'd say eating and painting one a day will make you happy and healthy!

STEP 01

Sketch the apple using outline 40 on page 236. Mix a very pale yellow and apply evenly to the entire shape of the fruit. Let dry.

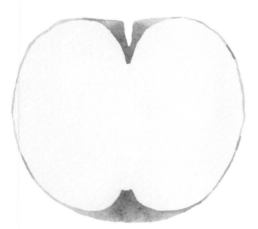

STEP 02

Mix a light green colour and paint the apple skin. Omit the area where the stem will be placed (see Step 4) and make the corners a more saturated shade of green to indicate depth.

STEP 03

Return to the pale yellow and add a touch more pigment to the mix. With thin brushstrokes, paint curved lines in the centre to give some shape to the apple core.

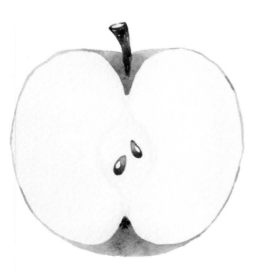

STEP 04

Switch to a smaller brush. Mix a brown colour and paint two tear-shaped apple pips inside the core remembering to leave a small white space for the highlights. Add the stem and the tiny 'hairs' at the bottom using the same colour.

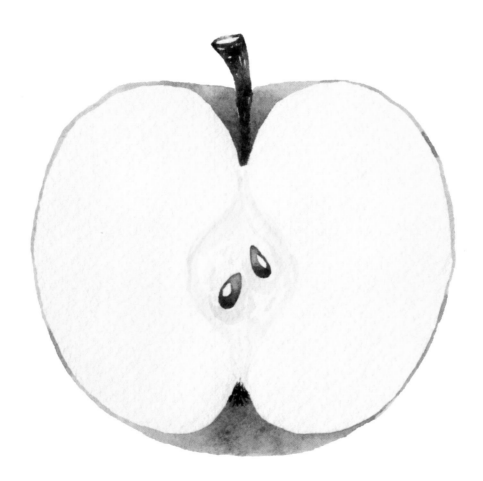

STEP 05

Add some details. I extended the stem to touch the apple flesh and went back to the pale yellow to increase the structure and shadows on the core, which also added texture.

Project 45

Fish

This illustration
may seem a bit
more complex, but
if you prepare your
colours beforehand
and practise
the wet-on-wet
technique, it will
bring you so much
joy. Carp-e diem!

STEP 01

Sketch the fish using outline 41 on page
237. Mix a few colours: pale diluted
yellow, red, blue and black. Using wet-
on-wet, cover the top two fish entirely
with a watery layer of pale yellow.

STEP 02

While the shape is still wet, drop in some blue paint at the top of the fish and some red at the bottom, connecting the two fish. Switch to black and paint the tails and fins.

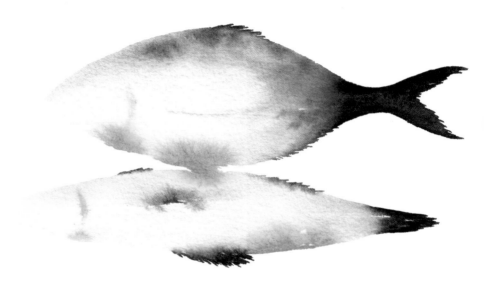

STEP 03

Paint the third fish, as described in Step 1. Connect it to the second fish at the fins.

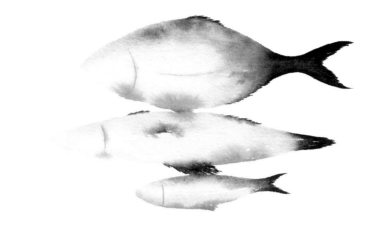

STEP 04

Start adding details by painting a thin red line on each fish, separating the head from the body.

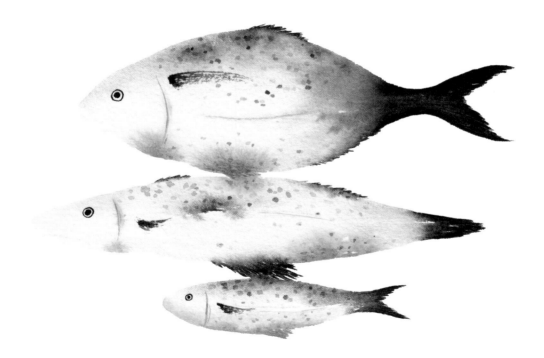

STEP 05

Add scales by painting scattered dots across the fish bodies. To do this, use semi-transparent mixes of the colours you used previously: a pale red, yellow and blue. Use the black to paint simple eyeballs.

Project 46

Seashell

Seashells have always fascinated me. I remember a big shell that decorated a mantelpiece in my childhood home – every time I put my ear to it, I swear I could hear ocean waves crashing!

STEP 01

Sketch the seashell using outline 45 on page 238. Mix a sandy yellow by combining yellow with some brown. Cover the entire shape with it, except for the shell interior, but do paint the edge of that section. Throughout the shape, vary the intensity of the paint by applying more saturated colour at the edges and diluting the paint in the middle of the shell. Let dry.

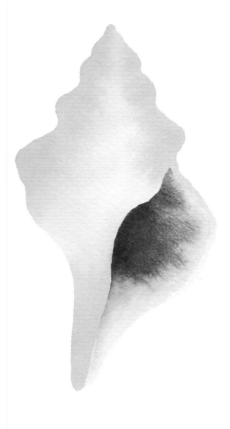

STEP 02

Mix some purple. Cover the shell interior with a clear layer of water and then drop the purple in the middle of the area using the wet-on-wet method. Let dry.

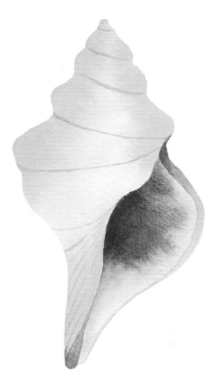

STEP 03

Go back to the sandy yellow mix, but this time add a touch more brown to make it darker. Start adding texture using thin brushstrokes and curved lines. Make the bottom tip of the shell darker, as well as the outline of the shell opening, to add contrast.

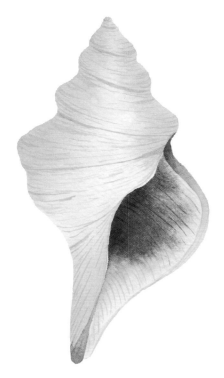

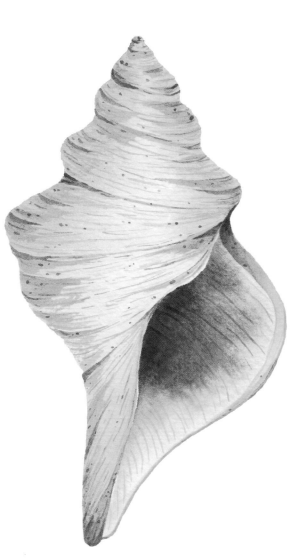

STEP 04

Add some very thin lines across the shell to create a more realistic texture, this time making the strokes shorter and as delicate as you can, so as not to overpower the illustration. Then go back to the purple paint and add thin lines inside the shell in a similar manner, making the curved lines parallel.

STEP 05

Add a little more brown to the mix you assembled in Step 3. Using little water, apply small irregular dots across the shell exterior for a pop of texture.

Project 47

Figs

Figs' distinct colours and textures make them one of my personal favourites for loose watercolour sketches. They make charming subjects for painting.

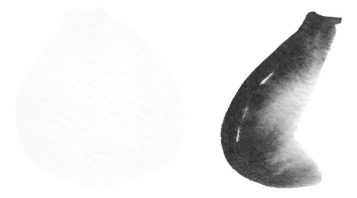

STEP 01

Sketch the figs using outline 42 on page 237. Mix a pale yellow, two tones of purple (with a blue and a red undertone) and some red. Start with the left-hand fig, covering it all in pale yellow. For the second one, load your brush with the bluish purple and paint the first half of the fig, making the edge darker and diluting the paint as you move towards the middle. Now quickly move on to Step 2.

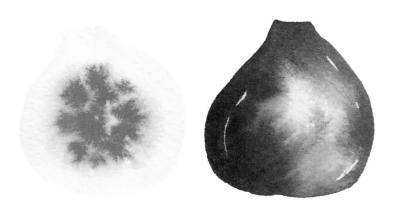

STEP 02

Before the figs dry, finish off the whole fig by applying the reddish purple to the other side of the fruit, merging the two tones of purple. Clean off your brush, load it up with red and put a few drops of the paint on top of the pale yellow fig if the area is still wet. If the yellow has already dried, apply a thin layer of clear water on the shape again and drop the red in the same manner. Let dry.

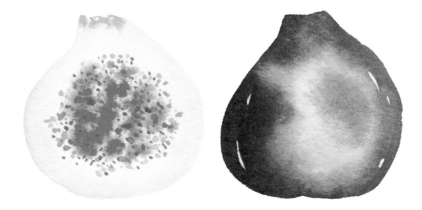

STEP 03

Mix a little light brown, a slightly darker red (you can add a tiny bit of green to it) and a light green. Paint the stems in brown using tiny brushstrokes. With the dark red, make irregular dot marks in the middle of the cut fig. Switch to the light green and add a gentle wash to the whole fig, where the lightest area of the fruit is.

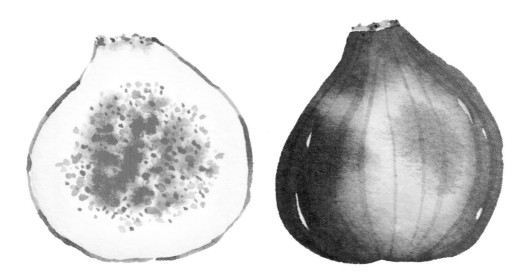

STEP 04

Mix a little dark brown and add texture to the stems by laying down a few dots. Go back to purple and add a thin outline to the cut fig to create the skin. Dilute the same purple a tiny bit and add a few curved lines on top of the second fig, after it has fully dried, to create texture.

Project 48

Green Leaves

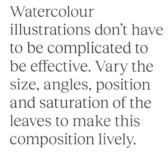

Watercolour illustrations don't have to be complicated to be effective. Vary the size, angles, position and saturation of the leaves to make this composition lively.

STEP 01

Mix a generous amount of green. Start by practising simple leaf forms made from two parallel strokes. Keep one stroke darker and richer in colour and dilute the pigment with extra water to paint the second part of the leaf.

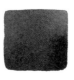

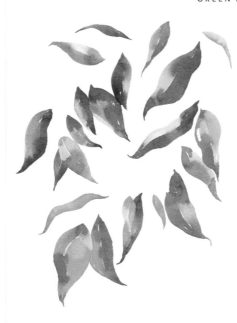

STEP 02

Sketch the leaves using outline 46 on page 238. Paint all the leaves. Some of them will be touching, so feel free to utilise the wet-on-wet method to make the leaves merge with each other.

STEP 03

Mix an earthy brown and use it to add the thin branches.

STEP 04

Once the leaves have dried, use diluted green to paint the leaf veins.

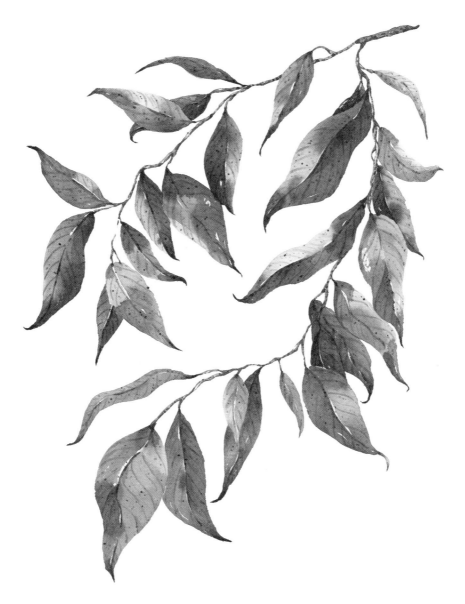

STEP 05

Using the same green, make dots all over the
leaves to add irregular texture.

Project 49

Coconut

A coconut is a striking subject because of the strong contrast between the white flesh and the brown textured shell. It may look intimidating at first, but follow these steps to simplify the process.

STEP 01

Sketch the coconut using outline 43 on page 237. Mix a very pale, nearly transparent grey using a diluted black with a small touch of blue. Paint the very middle of the coconut using the pale shade.

STEP 02

Stay with the pale grey and add some thin parallel lines to the rim of the coconut, to illustrate the flesh.

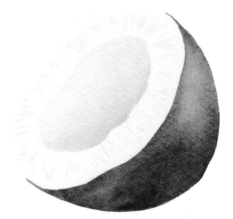

STEP 03

Mix a deep warm brown and lay it onto the coconut shell, varying the intensity of the colour. Dilute the brown for certain parts of the shell, such as the top corner, and then make it darker in other areas.

STEP 04

Use the same brown as a base and add a bit of black to create a dark brown. Paint a circular line on the rim of the coconut between the brown shell and the white flesh. Let dry.

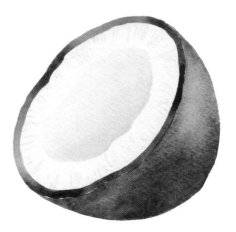

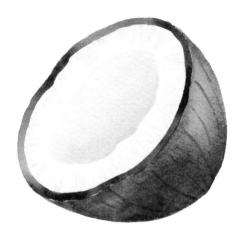

STEP 05

Stay with the same dark brown but dilute it with water. Paint a few curved lines on the coconut shell.

STEP 06

Switch to a smaller brush. Still using the lighter brown from Step 5, add thin lines randomly across the coconut shell to imitate its hairy texture.

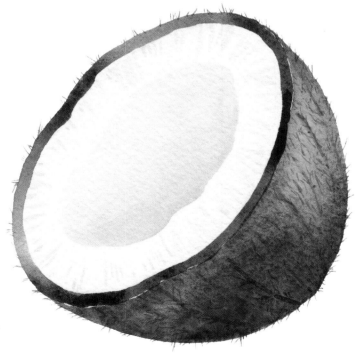

Project 50

Painting Palette

This last exercise is here to inspire you to keep experimenting with watercolours – a painting palette to manifest your creative growth! I hope I have managed to show you just how wonderful this medium is.

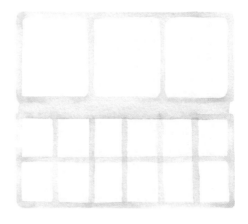

STEP 01

Sketch the palette using outline 47 on page 239. Mix a very pale grey colour and paint the outlines of the palette, including the middle sections.

STEP 02

Using the same pale grey colour, fill in the three mixing well gaps to give the palette dimension. Let dry.

STEP 03

Fill in all the wonderful colours of your palette!

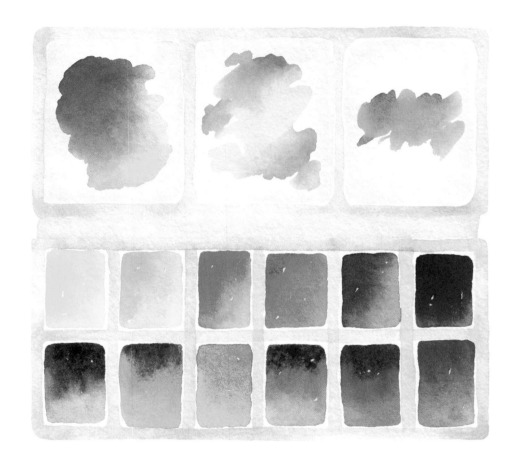

STEP 04

Add some colour swatches to the mixing wells. The best
inspiration for this is your own painting palette in front of you
– what colours can you see on yours?

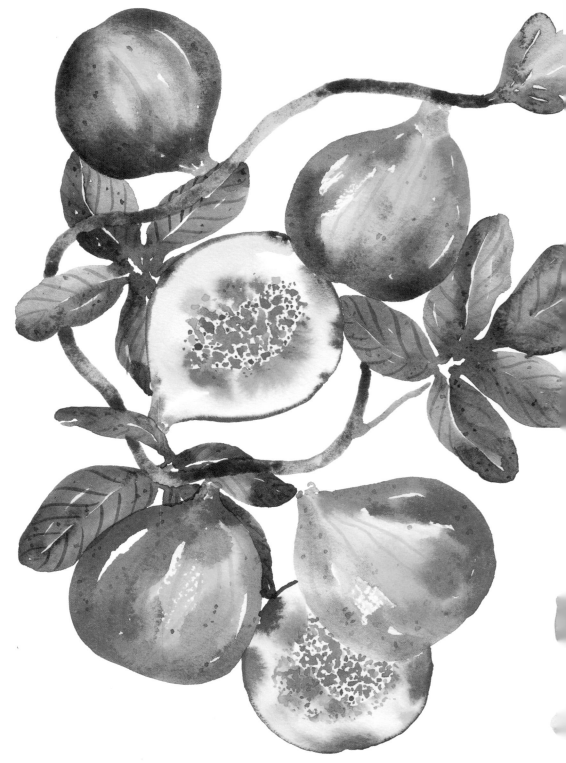

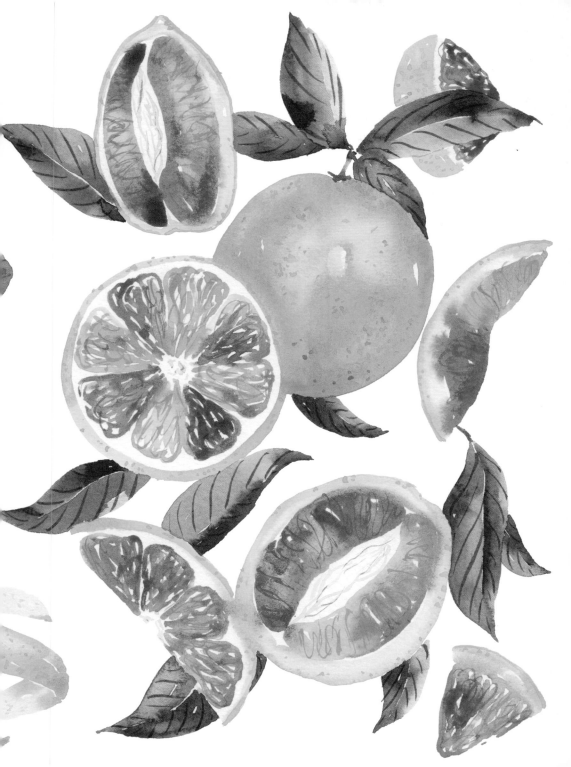

01.

03.

02.

04.

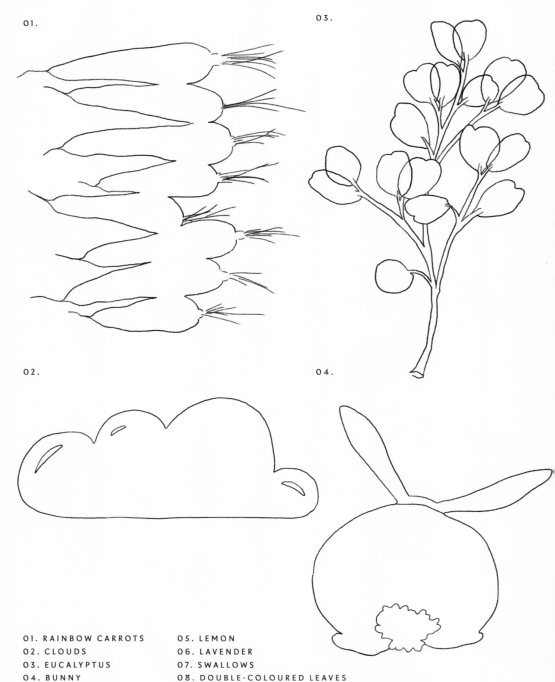

01. RAINBOW CARROTS 05. LEMON
02. CLOUDS 06. LAVENDER
03. EUCALYPTUS 07. SWALLOWS
04. BUNNY 08. DOUBLE-COLOURED LEAVES

06.

05.

07.

08.

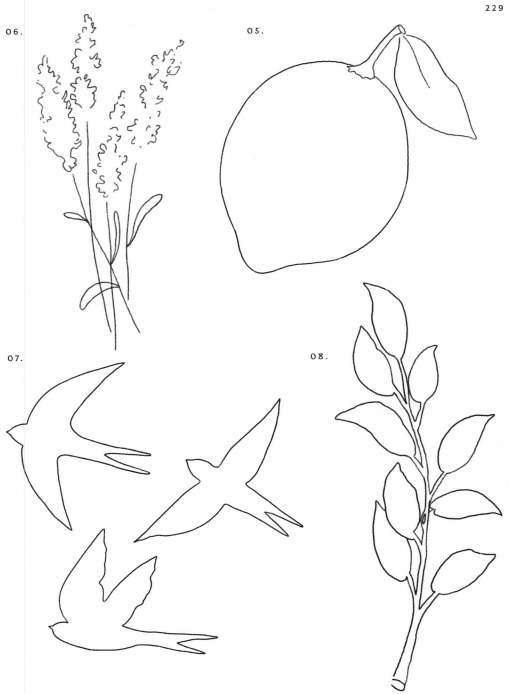

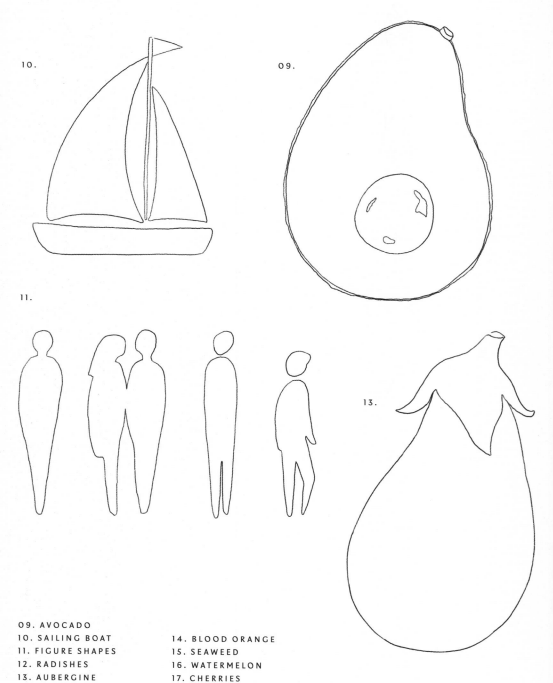

10.

09.

11.

13.

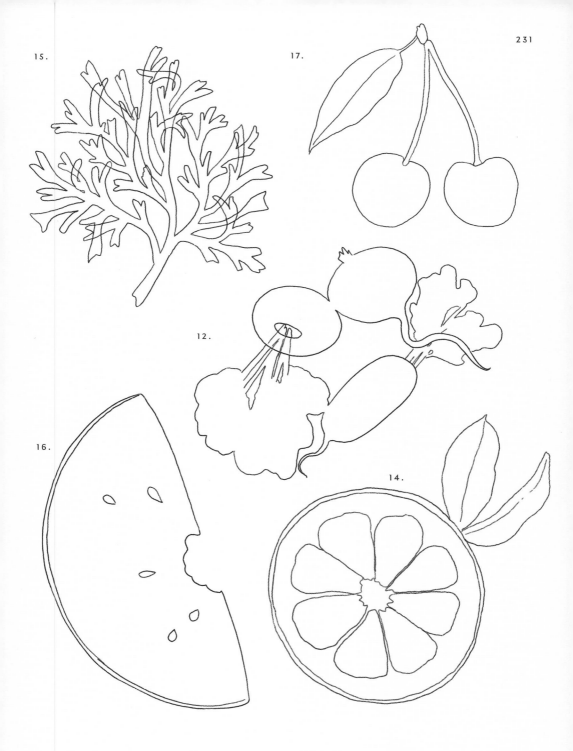

15.

17.

12.

16.

14.

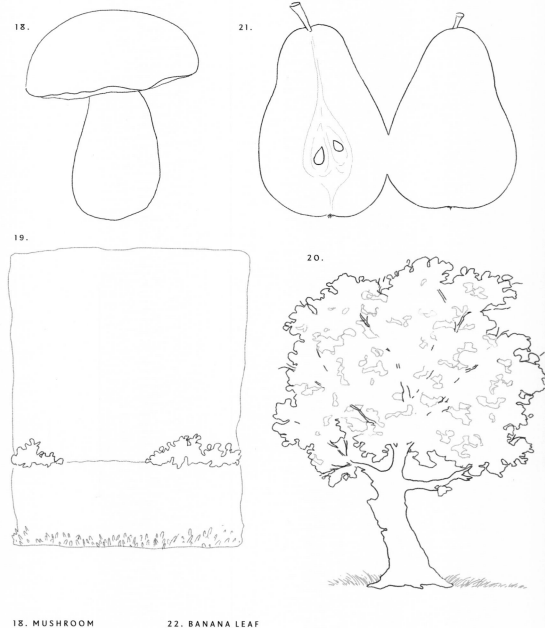

18.

21.

19.

20.

18. MUSHROOM
19. SIMPLE LANDSCAPE
20. GREEN TREE
21. PEARS

22. BANANA LEAF
23. BANANA
24. GRAPEFRUIT
25. FESTIVE HOLLY

22.

24.

23.

25.

26.

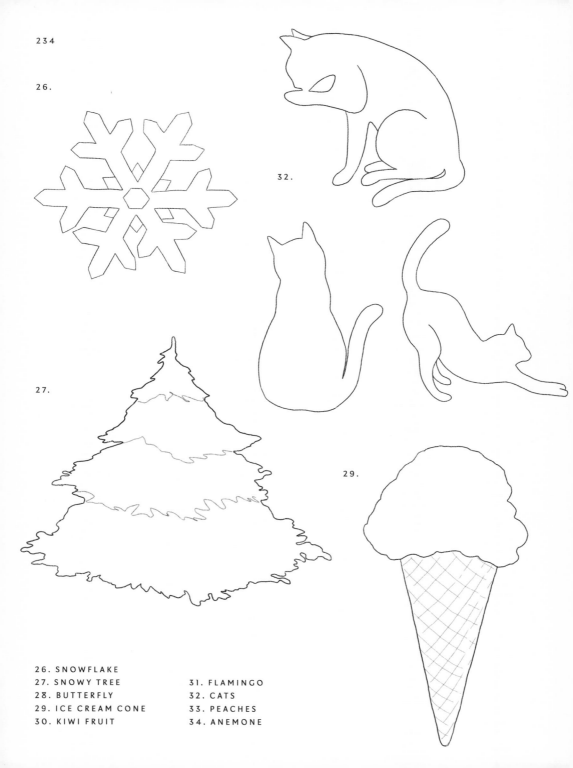

32.

27.

29.

26. SNOWFLAKE
27. SNOWY TREE 31. FLAMINGO
28. BUTTERFLY 32. CATS
29. ICE CREAM CONE 33. PEACHES
30. KIWI FRUIT 34. ANEMONE

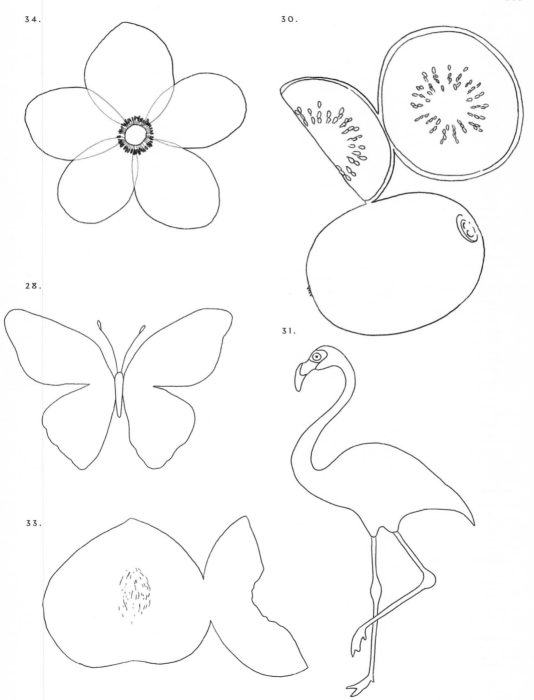

34.

30.

28.

31.

33.

35.

36.

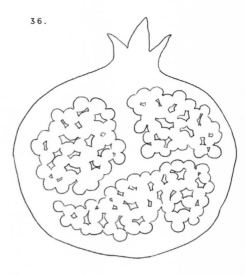

39.

37.

40.

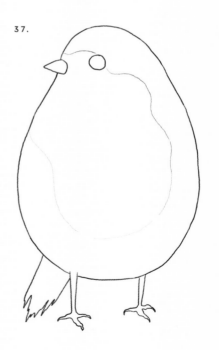

35. HIBISCUS
36. POMEGRANATE
37. ROBIN 40. APPLE
38. SWISS CHEESE PLANT 41. FISH
39. SAUSAGE DOG 42. FIGS
 43. COCONUT

41.

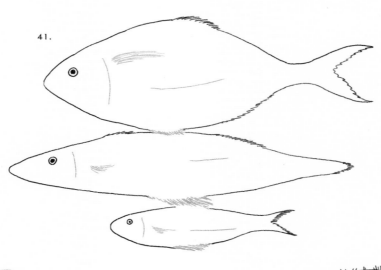

38.

43.

42.

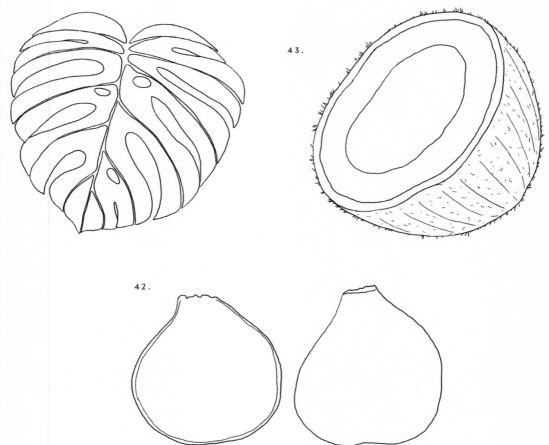

46.

45.

44.

44. WHALE
45. SEASHELL
46. GREEN LEAVES
47. PAINTING PALETTE
48. LOOSE FLOWERS

47.

48.

About
the Author

Jola Sopek was born in Łódź, Poland and currently resides in Brighton, UK. She works freelance as a watercolourist and specialises in food, nature and botanical illustration. Her work is characterised by vibrant colour palettes, attention to detail and playful compositions where realism and abstract looseness work seamlessly together. As a self-taught artist, she is a big believer that daily painting practice is the ultimate path to creative progress. Find more of her work online, especially on Instagram at @jolapictures.

Acknowledgements

I'd like to say a big thank you to my editors Kate and Chelsea for approaching me for this awesome project, being supportive throughout the process, and for granting me the creative freedom to write a book that is truly reflective of my approach to art making. Thank you to Double Slice Studio for all your hard work assembling the publication and making it look so fresh and joyful!

A very special thank you to my closest family and friends for your encouragement in my work and this creative journey throughout the years, and to Bradley for his loving patience and an unwavering belief in me.

Last but not least, thank you to every single person who ever cheered me on by viewing and taking an interest in my illustration, commissioned a project, took part in a workshop – none of this would be possible without your incredible support.